WALLS NOTEBOOK

BY SHERWOOD FORLEE

QUIRK BOOKS

PHILADELPHIA

100 TRINITY PLACE

Copyright © 2009 by Sherwood Forlee

Library of Congress Cataloging in Publication
Number : 2008932635

ISBN : 978 - 1 - 59474 - 324 - 5

Printed in Singapore

Designed by Sherwood Forlee & Doogie Horner
Production by John J. McGurk
Photography by Sherwood Forlee

Distributed in North America by Chronicle Books
680 Second Street
San Francisco , CA 94107

10 9 8 7 6 5 4 3 2 1

QUIRK BOOKS
215 Church Street
Philadelphia , PA 19106
www.quirkbooks.com

I guess this will be just the start of my thoughts. I have so much to say. I met someone and life has made 180° turn for me. Is crazy how you can meet someone and fall in love so quick.

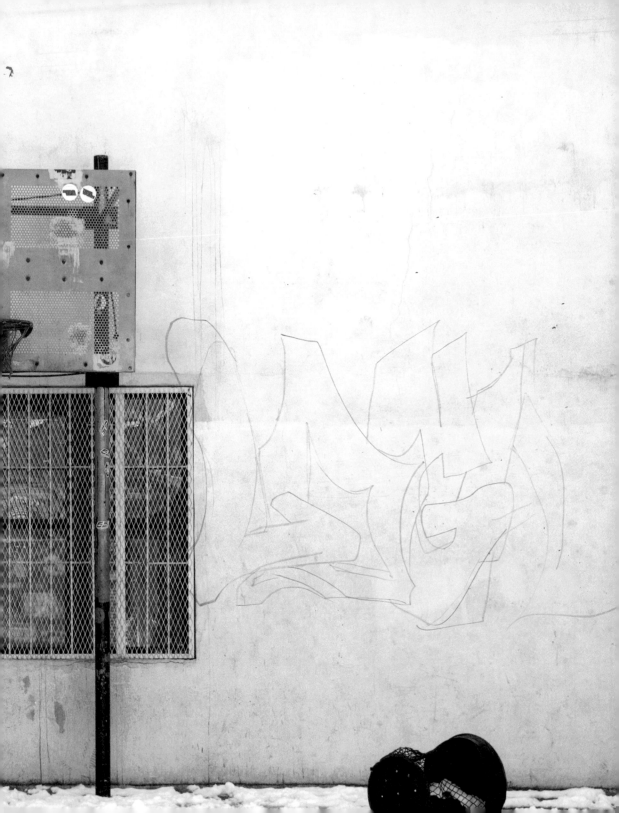

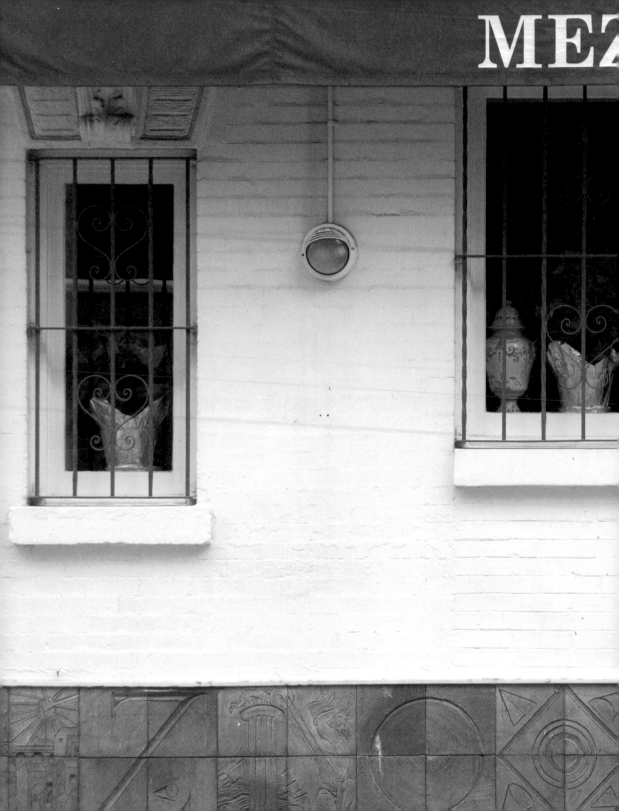

MEZ

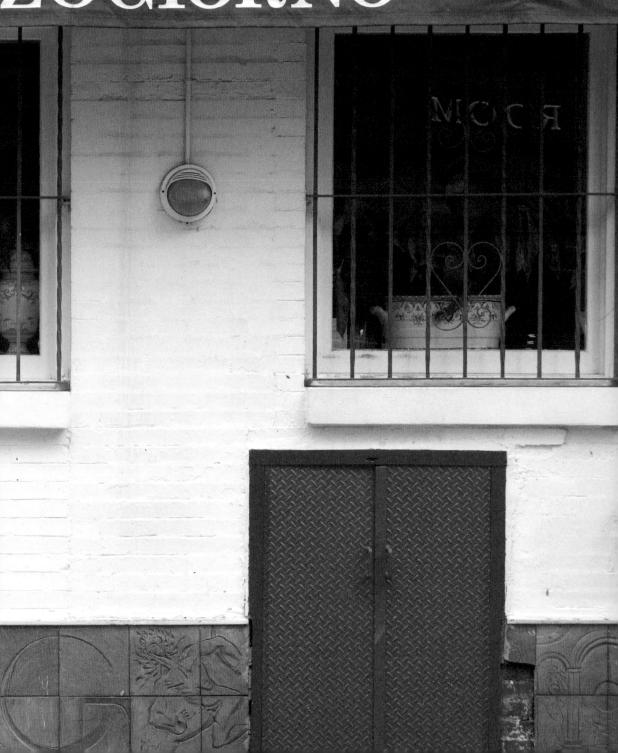

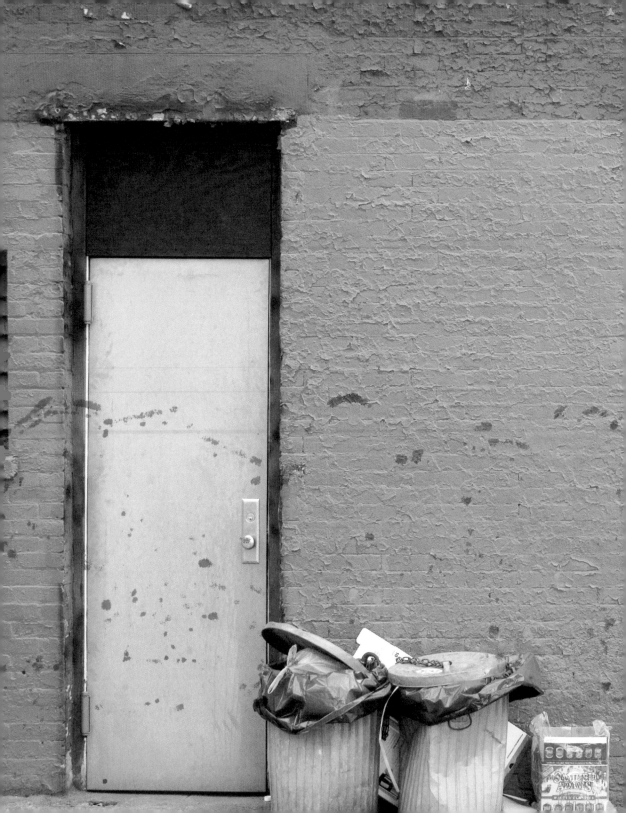

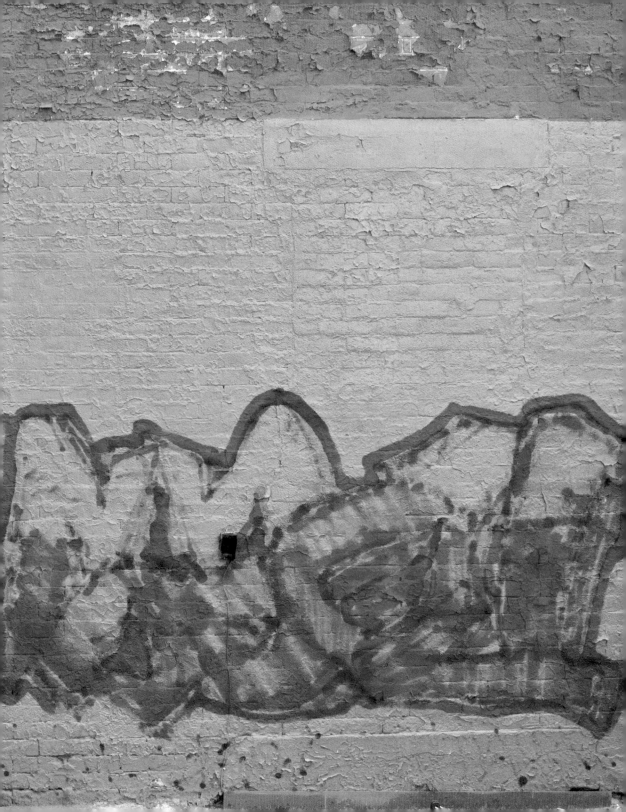

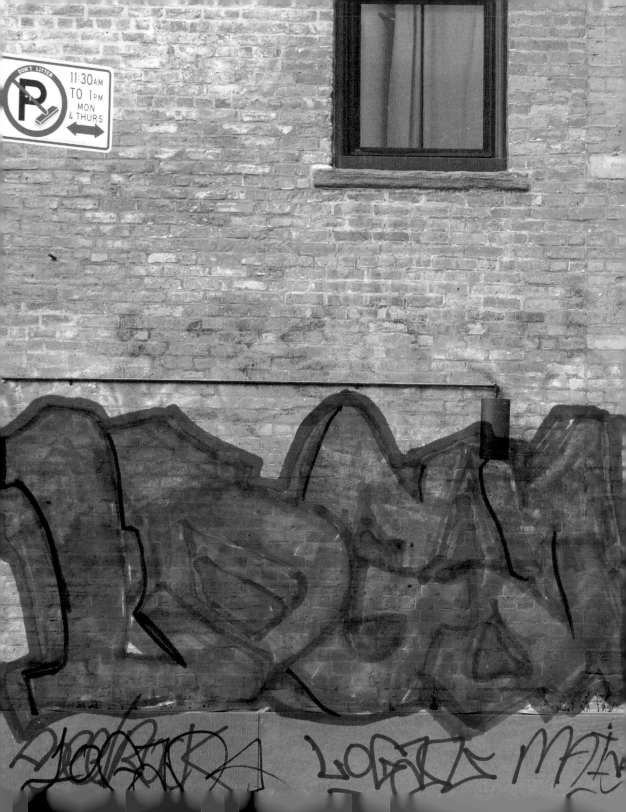

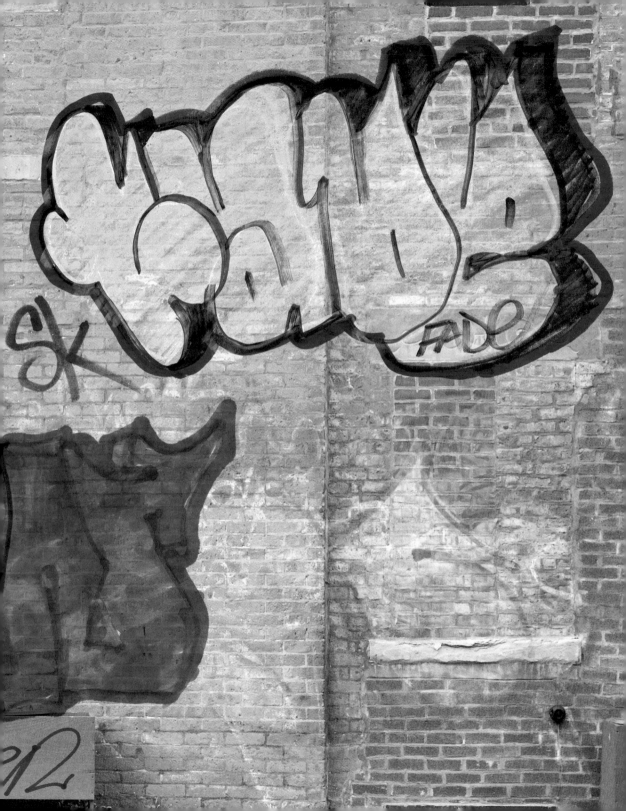

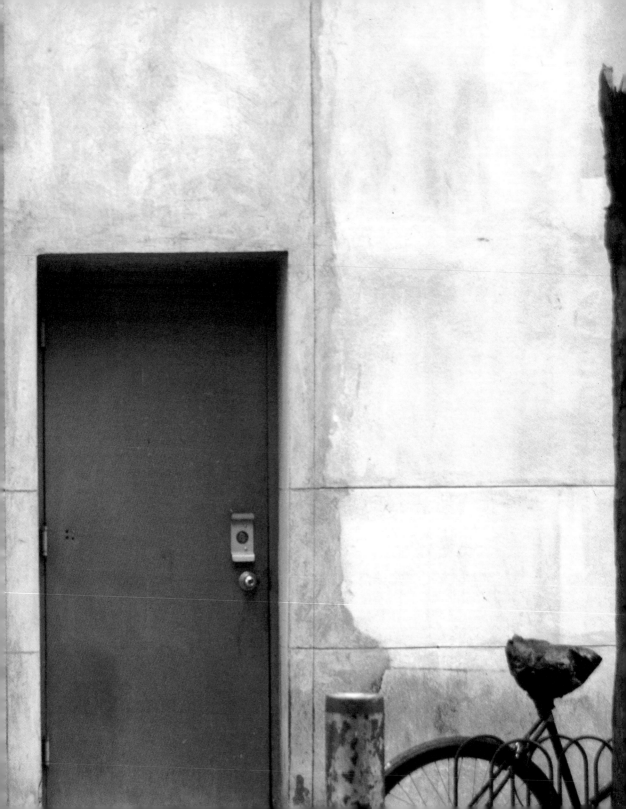

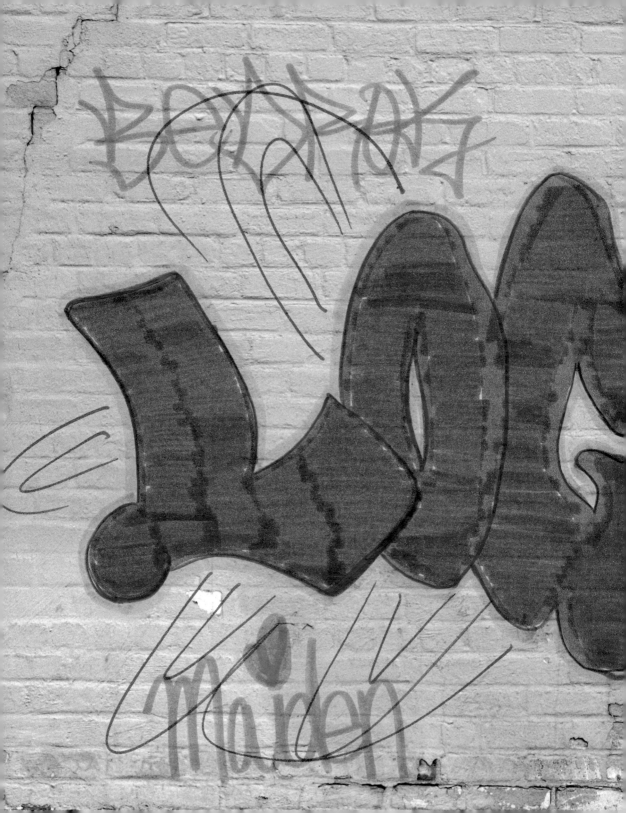

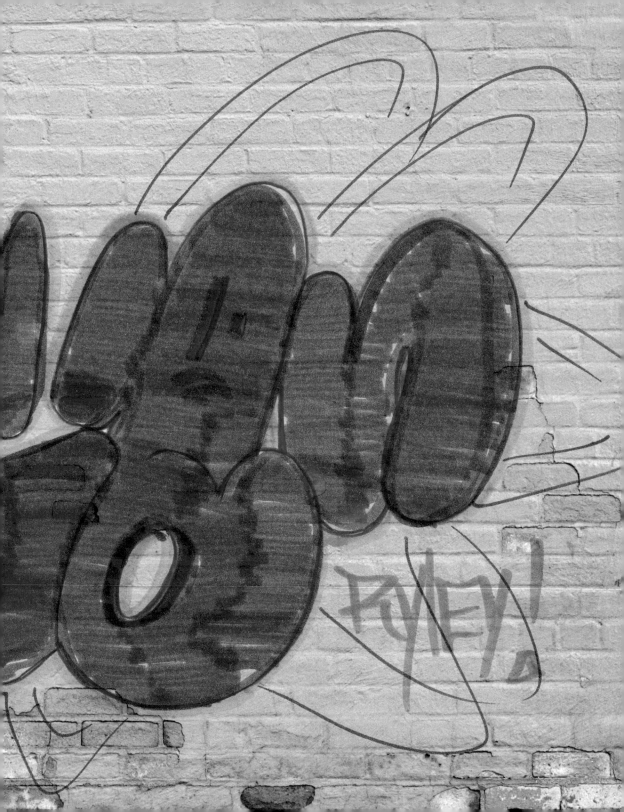

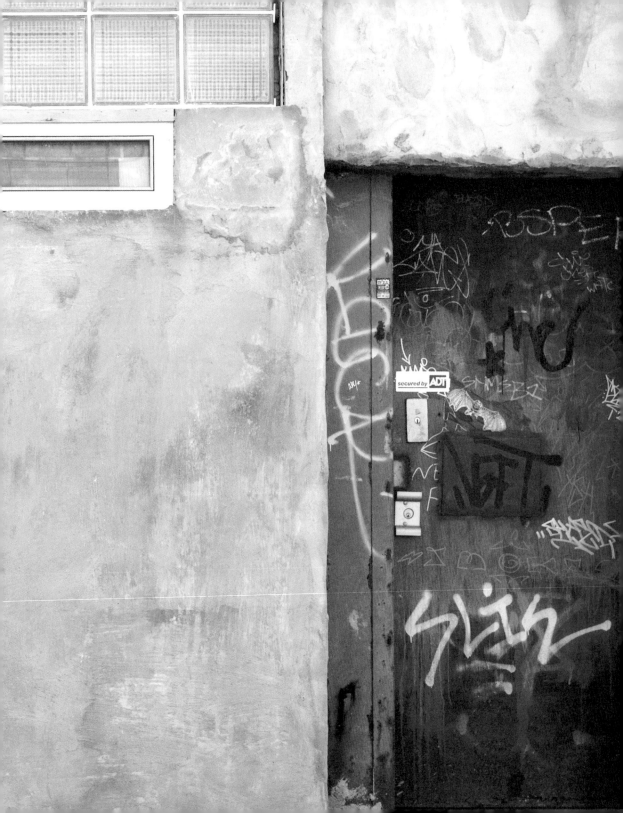

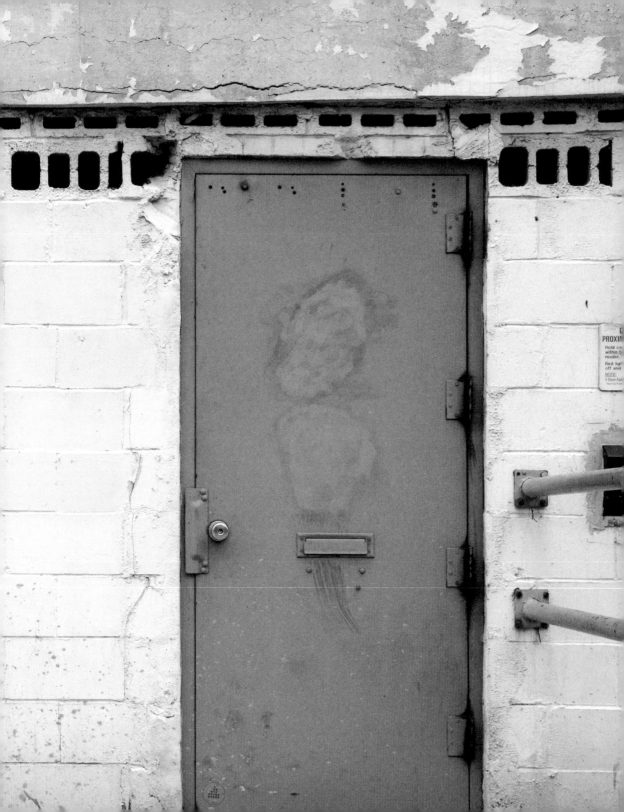

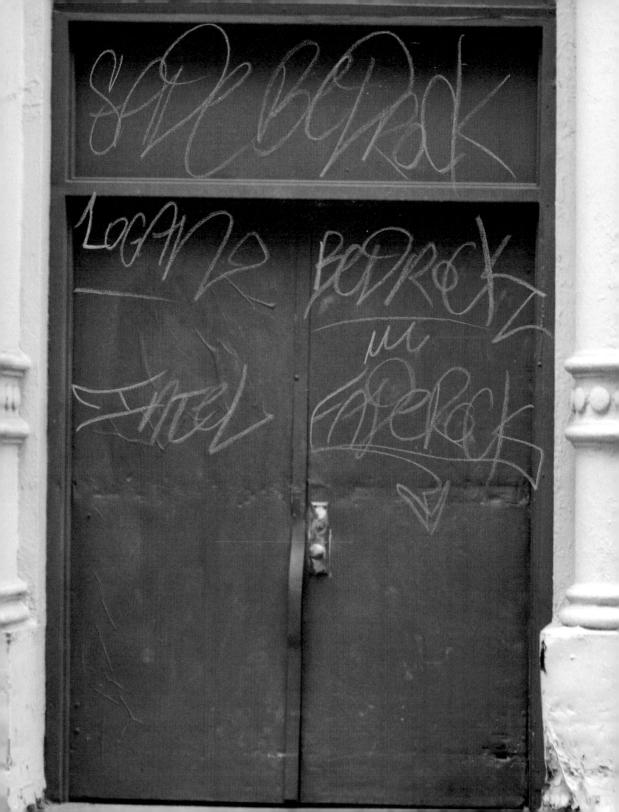

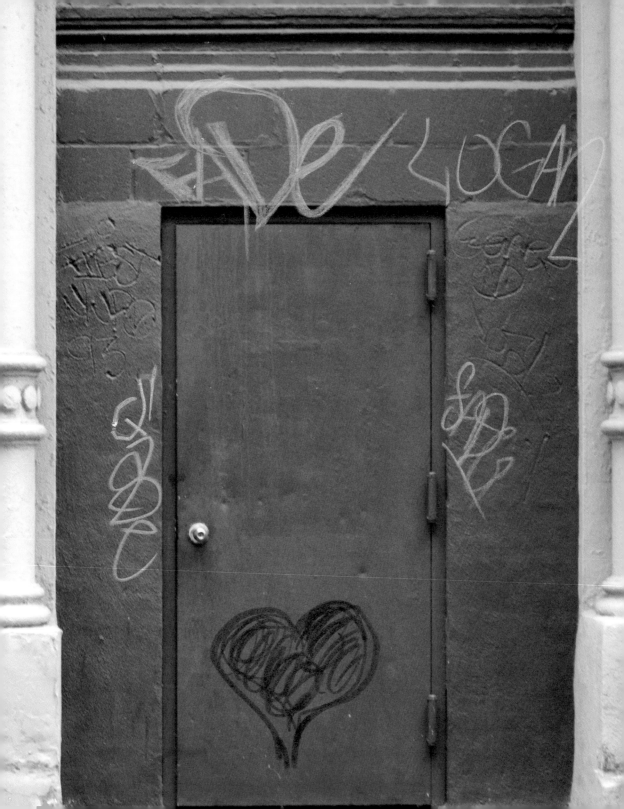

AN EDUCATED CONSUMER IS OUR BEST C

SYMS

SPRINKLERS
THROUGHOUT
BUILDING

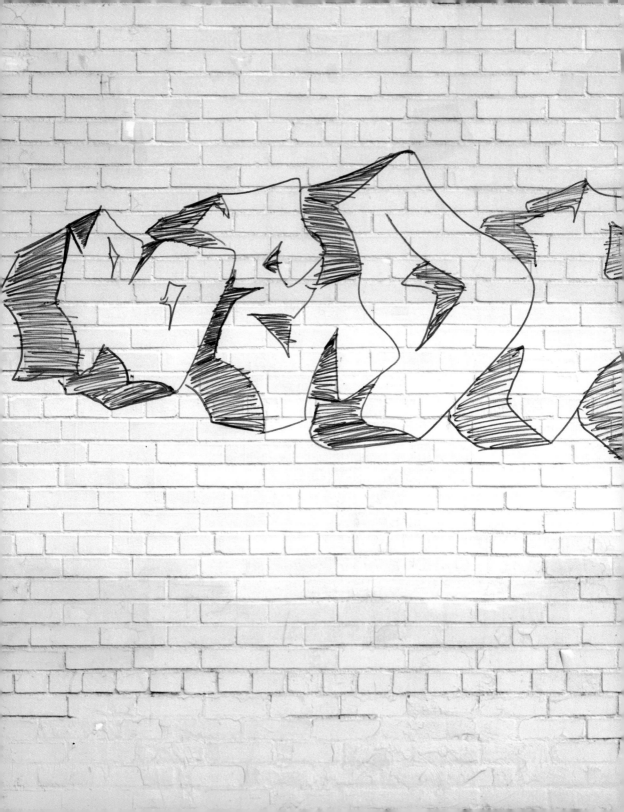

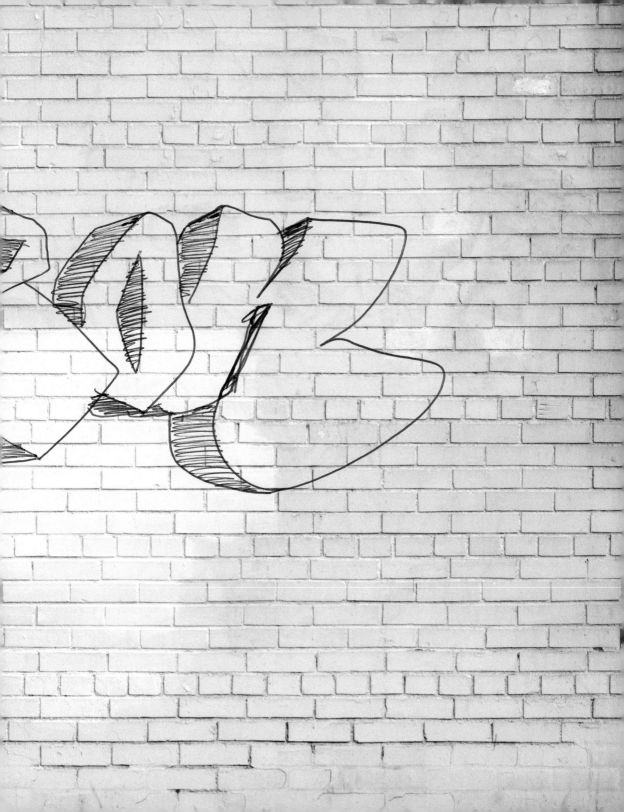

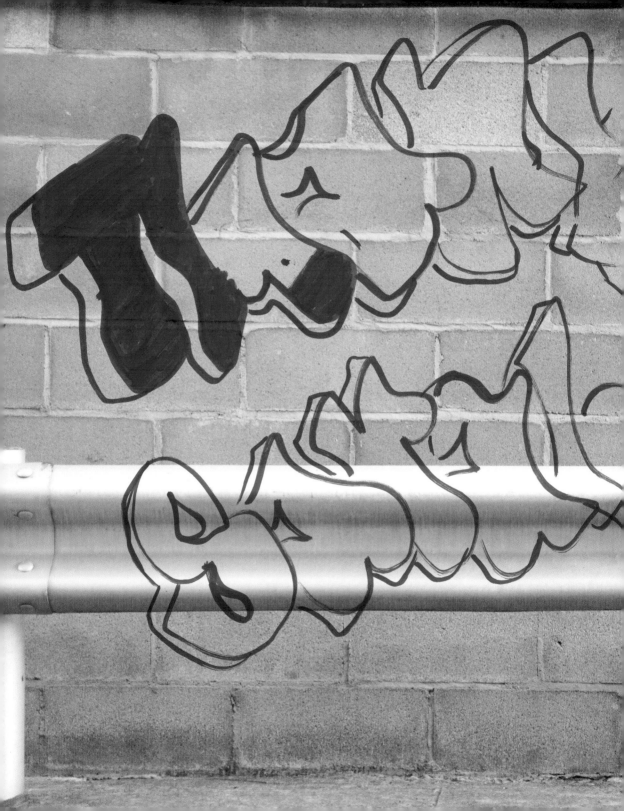

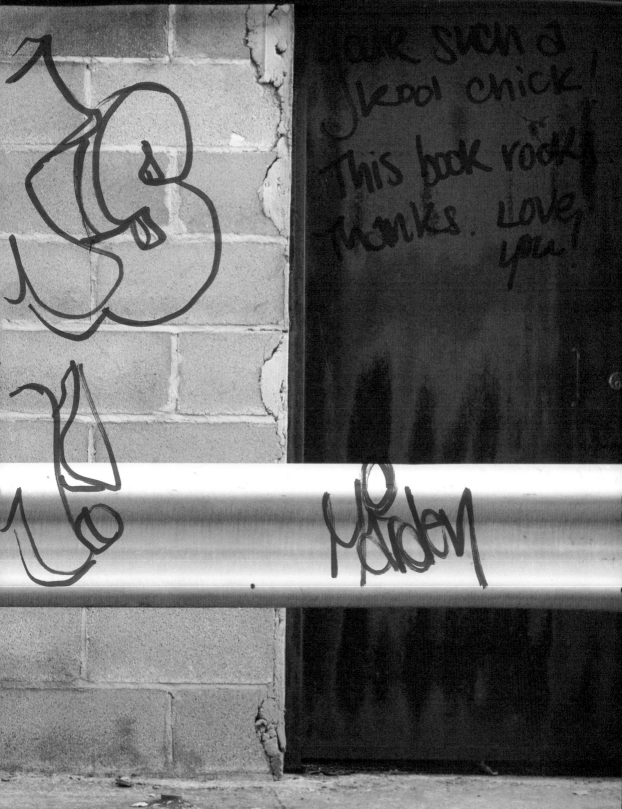

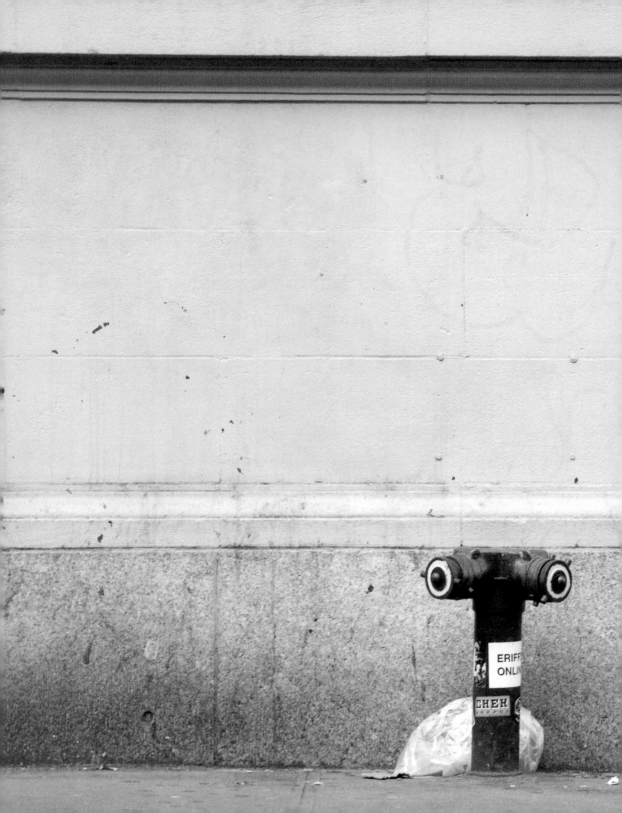

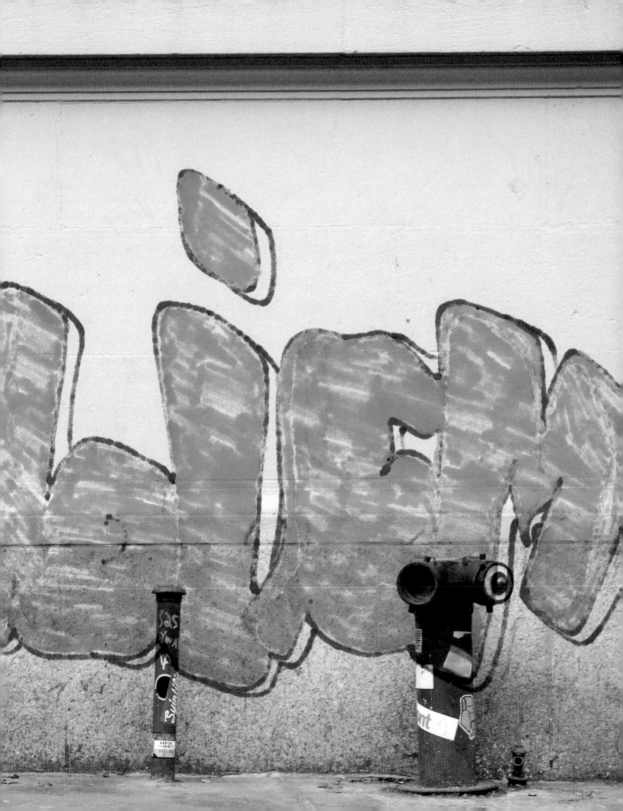

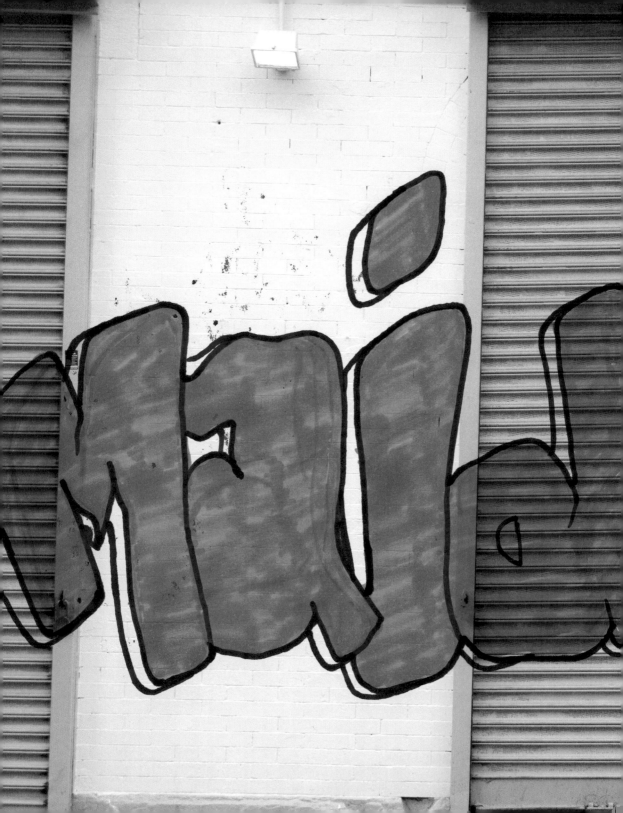

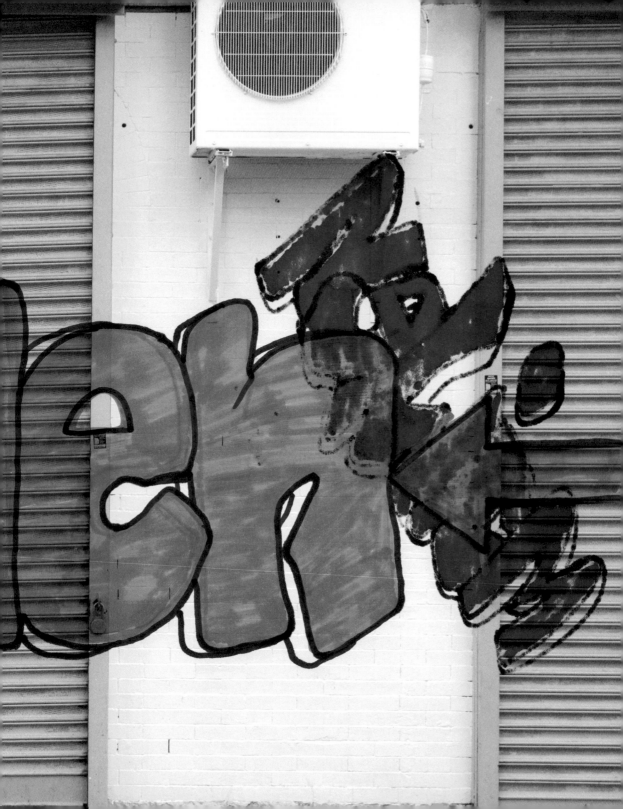

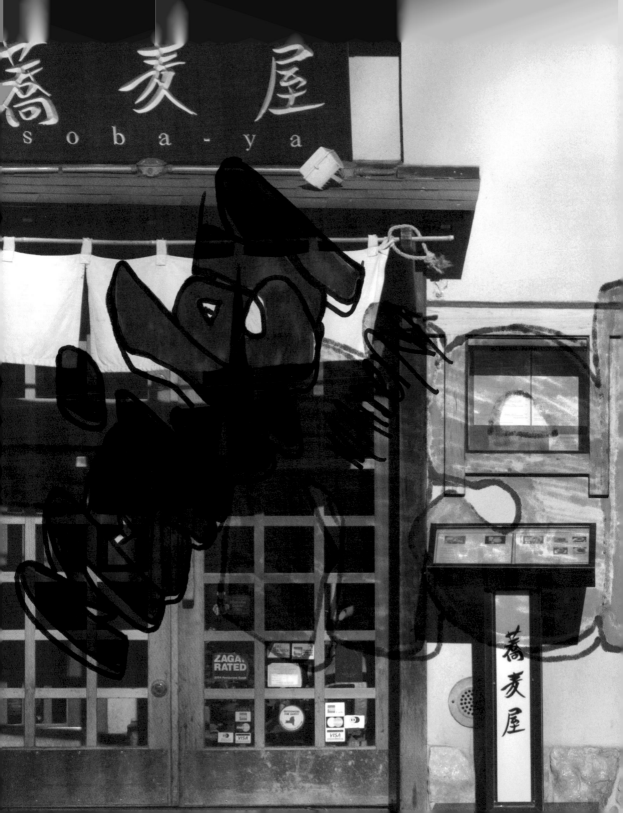

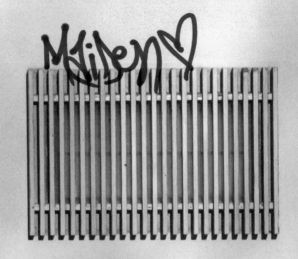

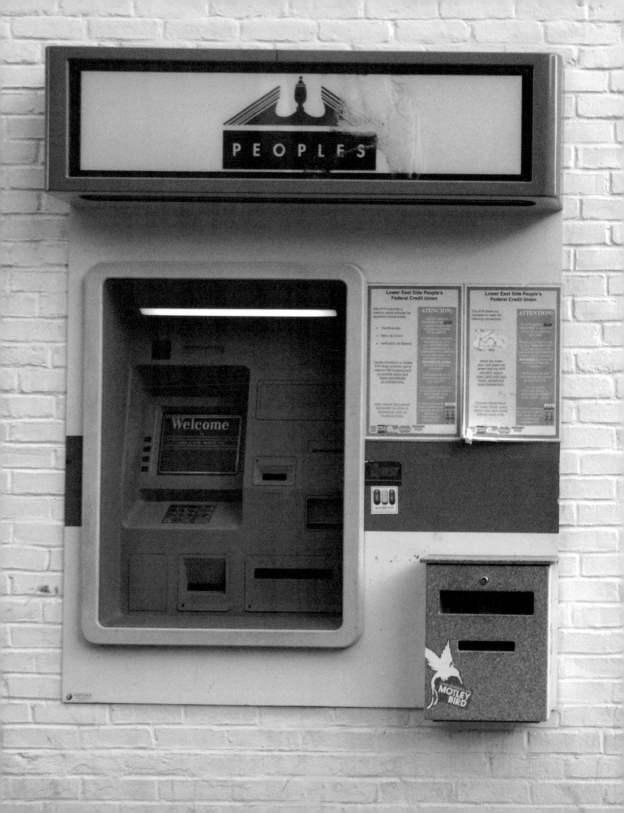

CENTER

Ltd.

5346

Side

P APTS

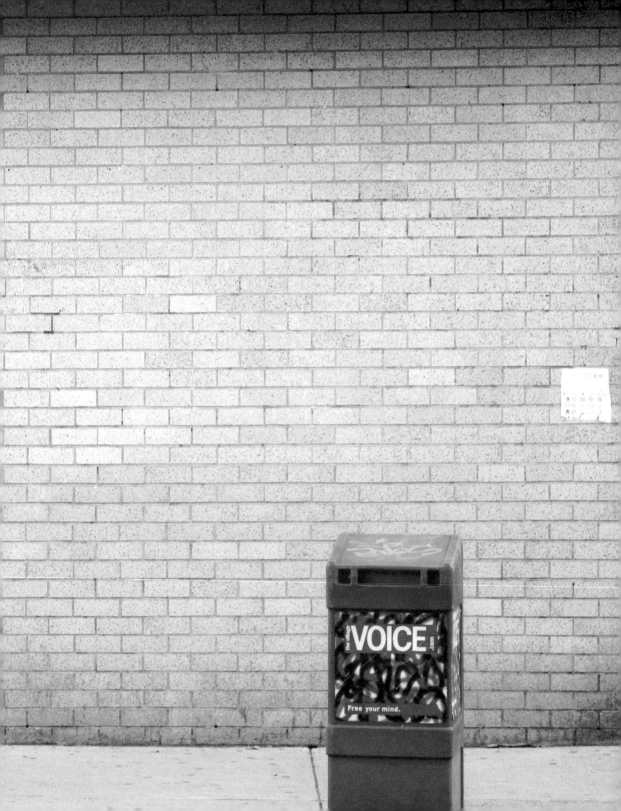

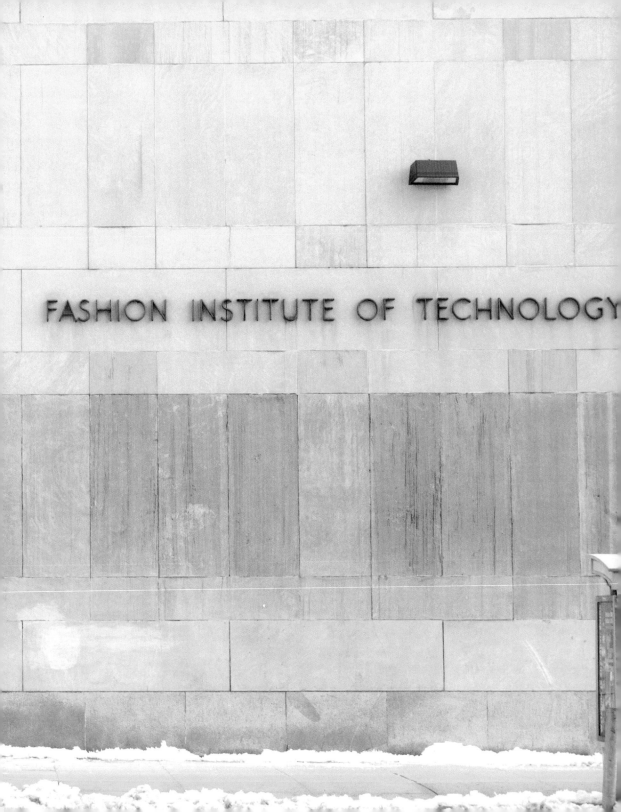

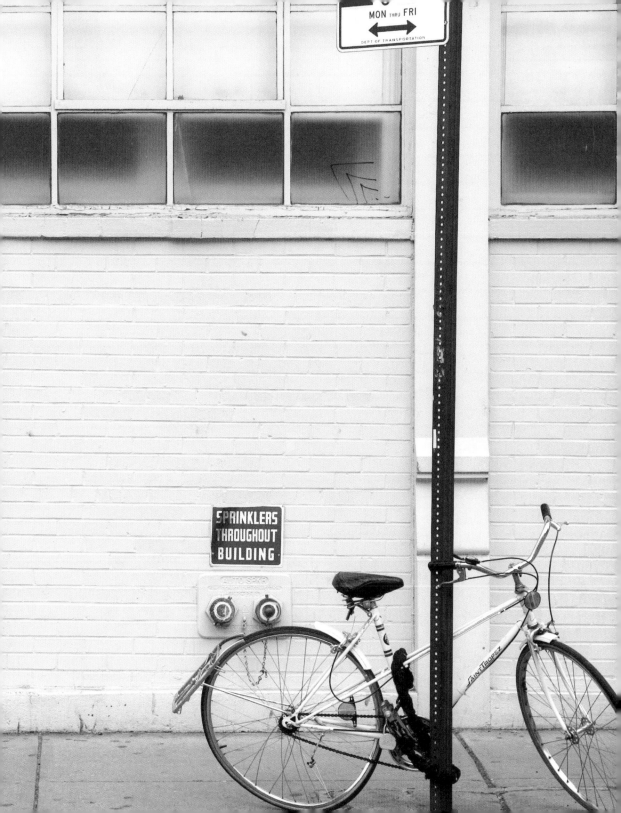

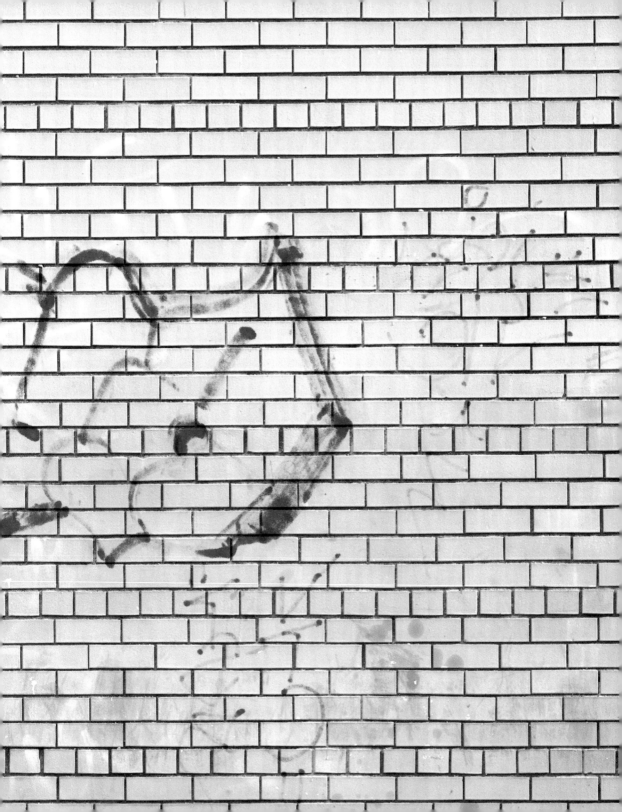

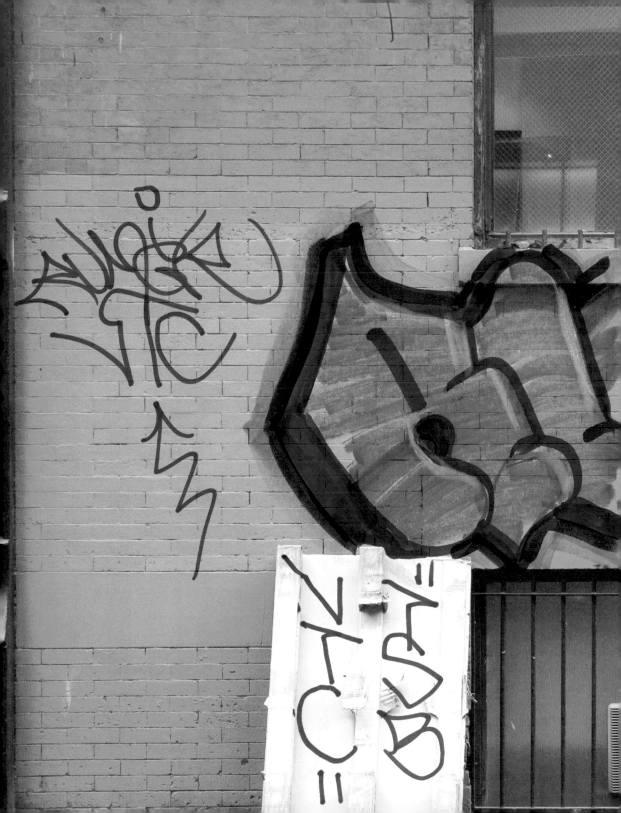

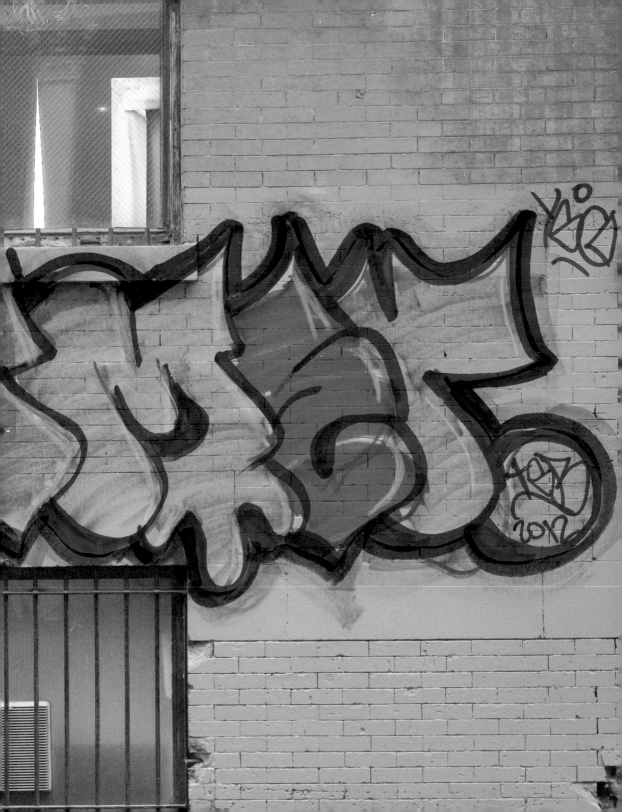

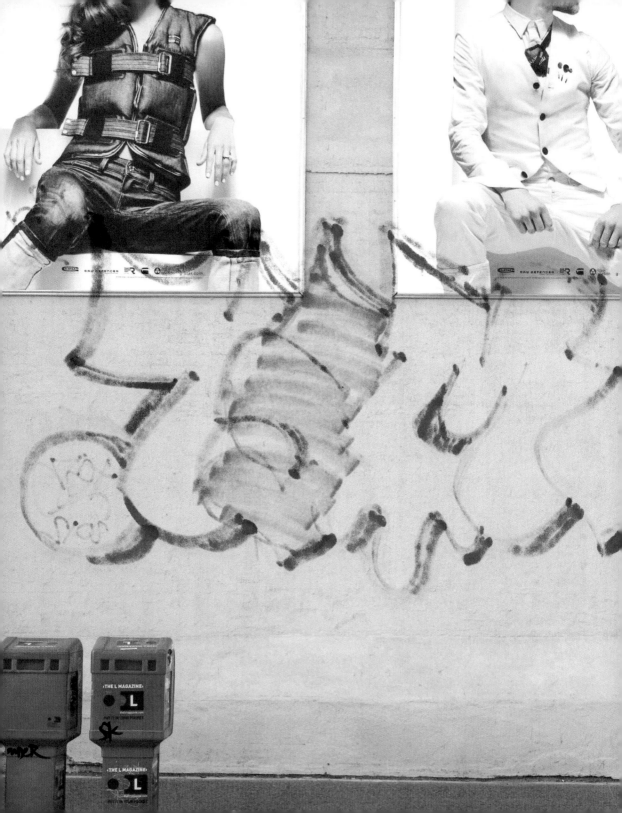

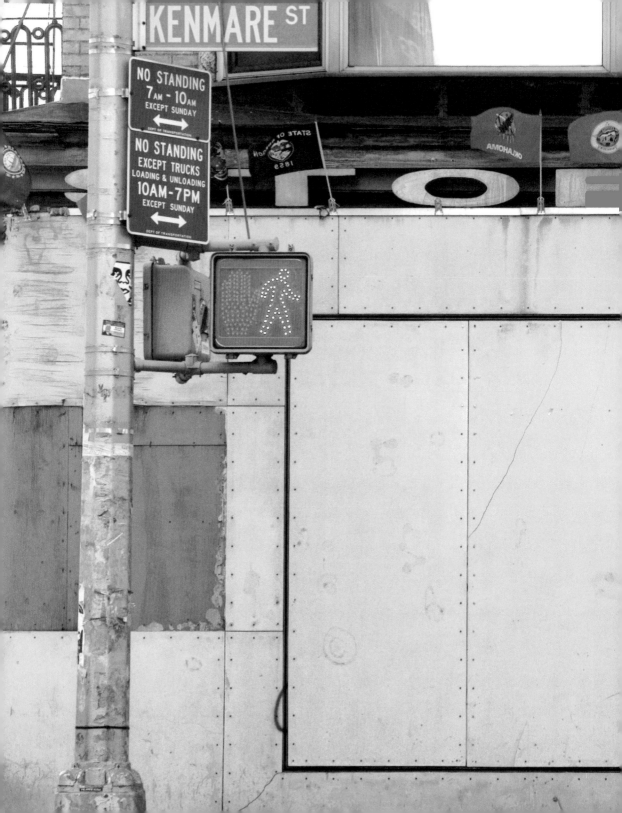

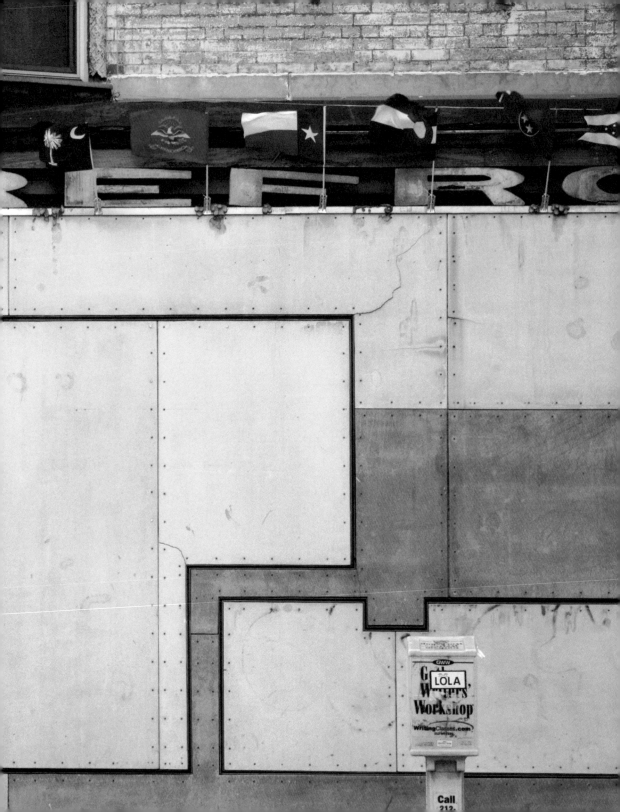

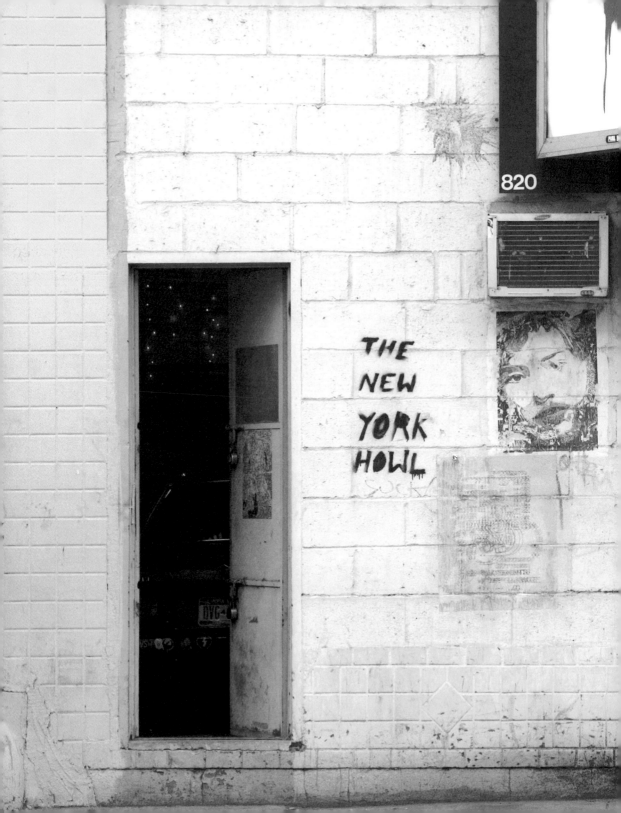

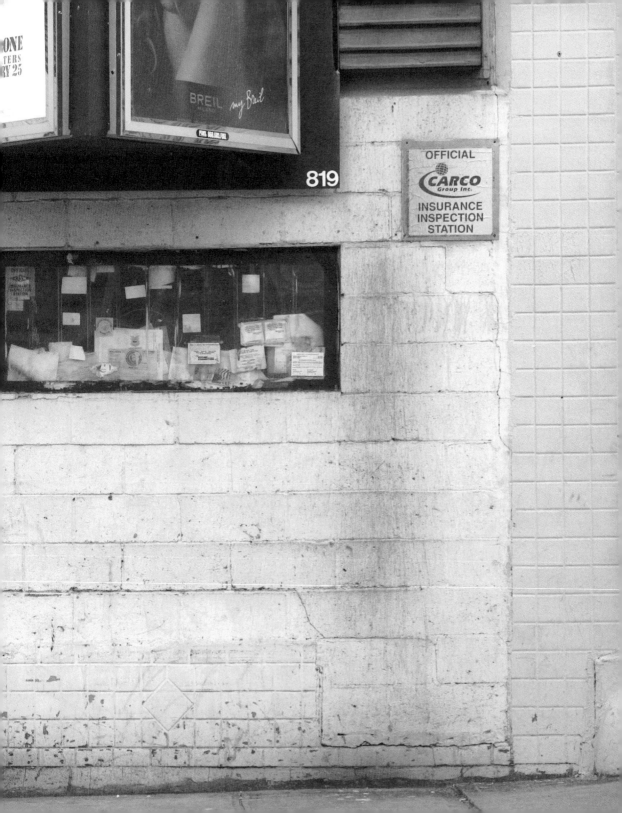

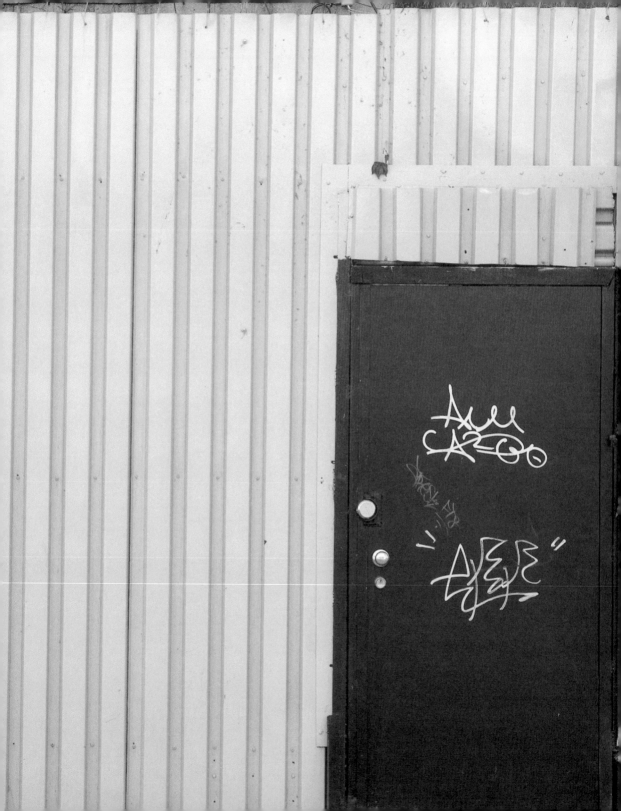

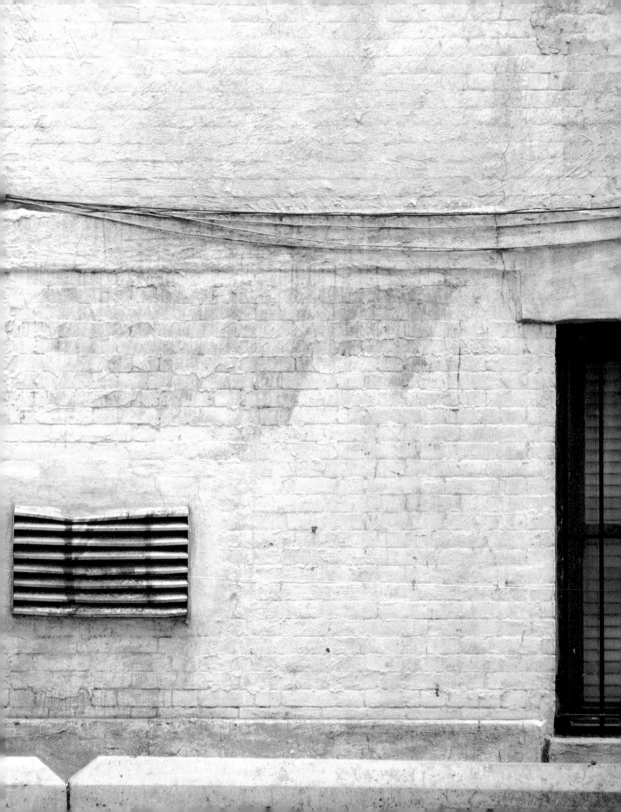

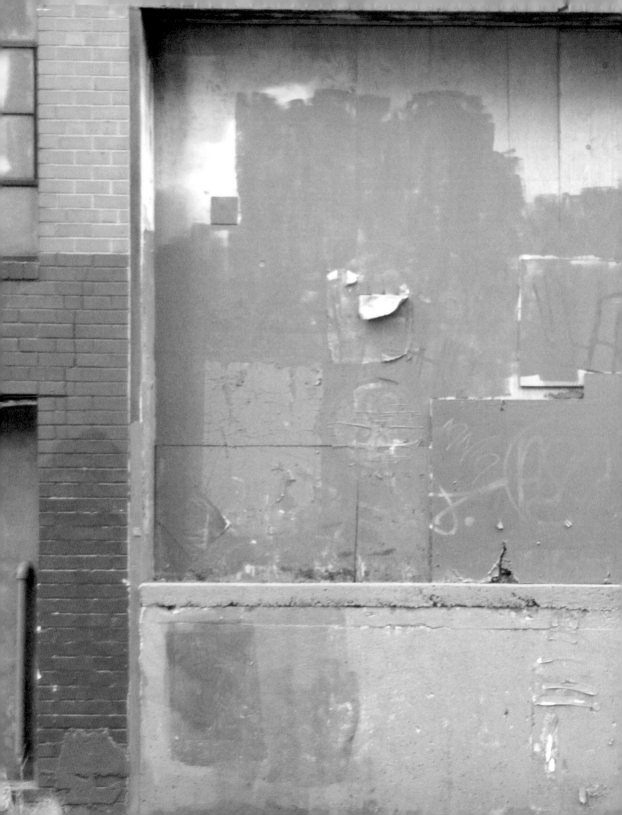

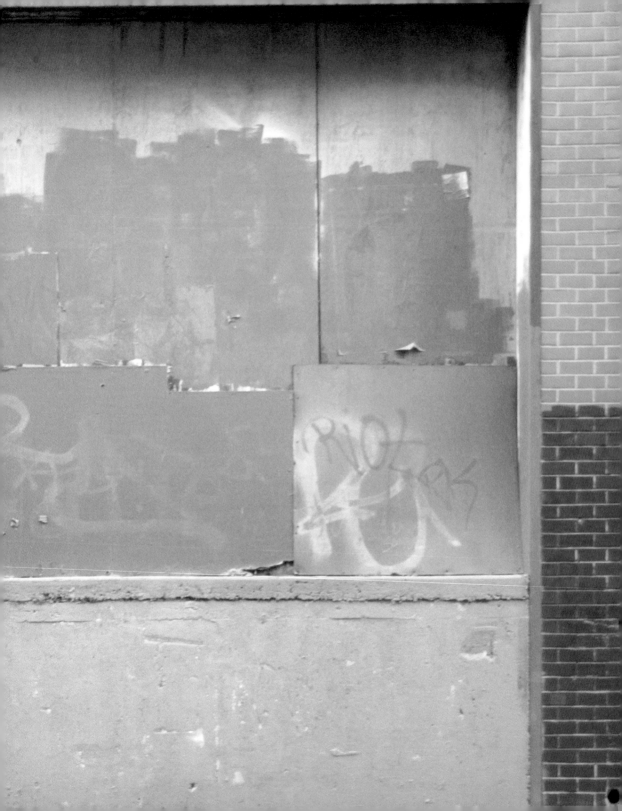

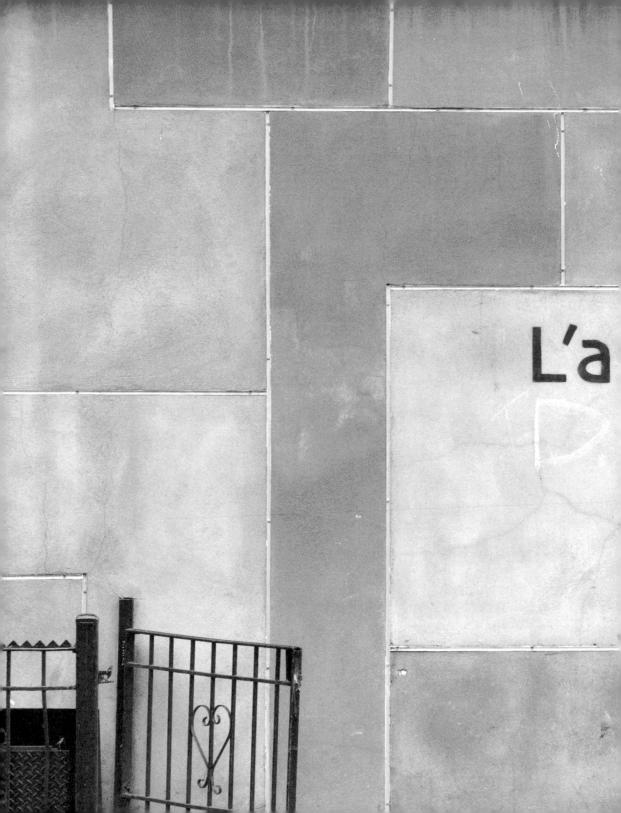

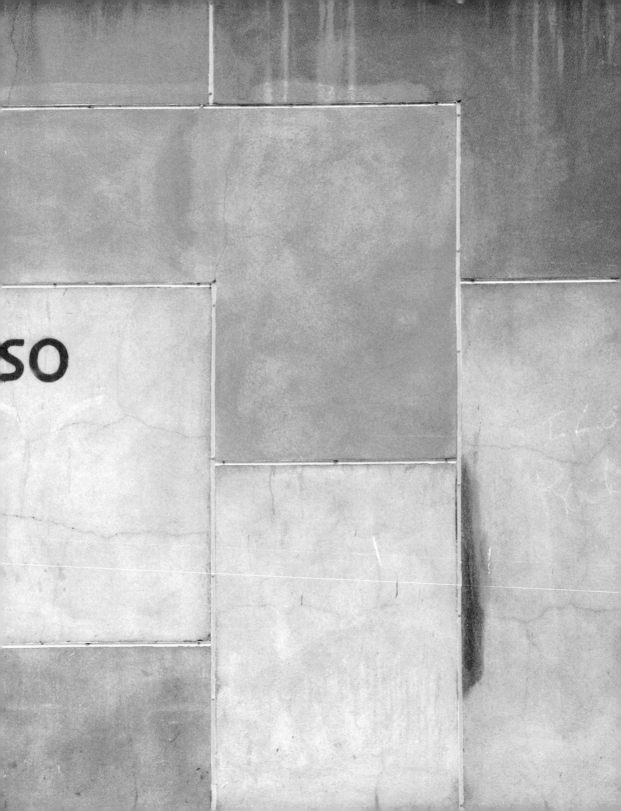

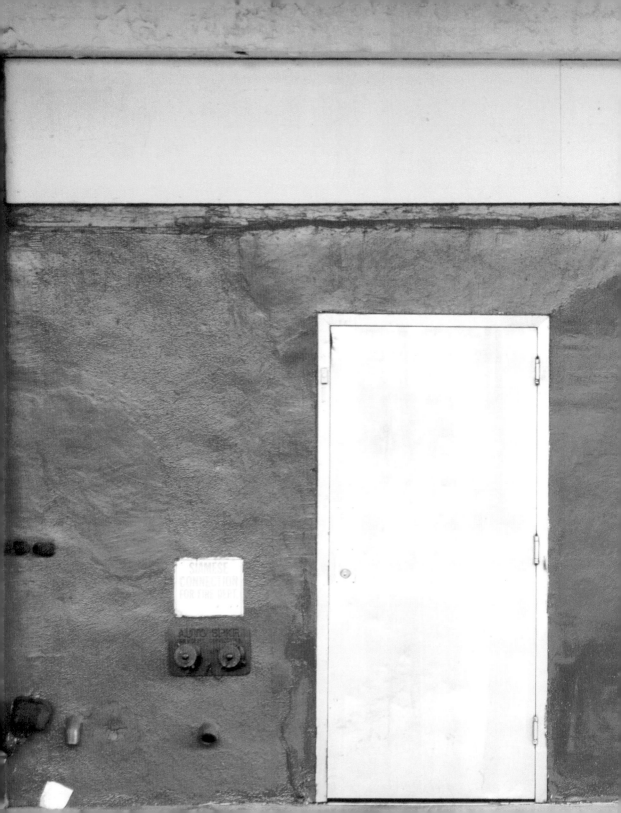

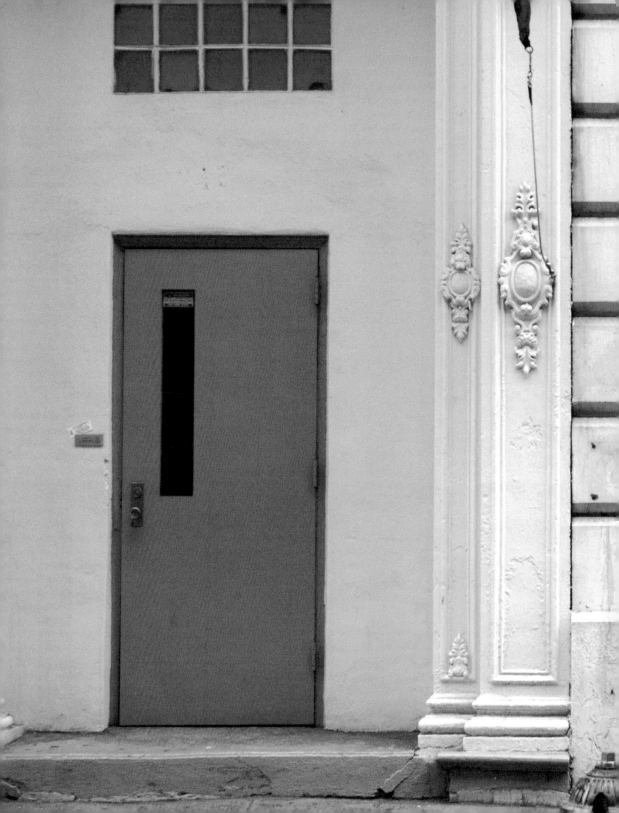

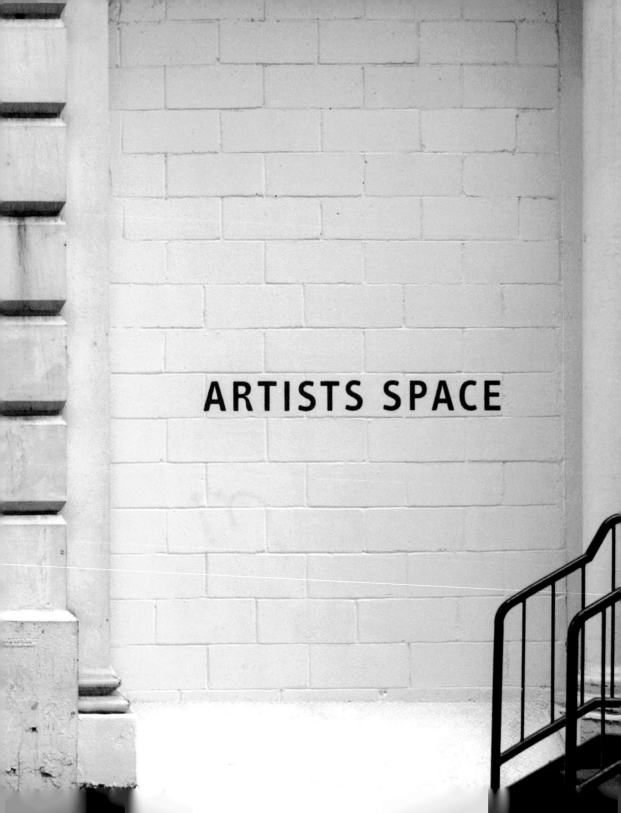

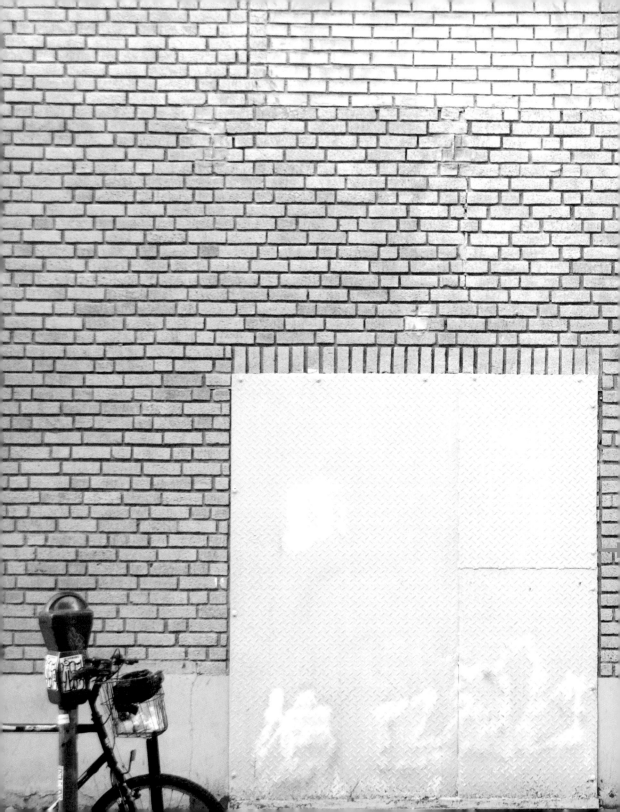

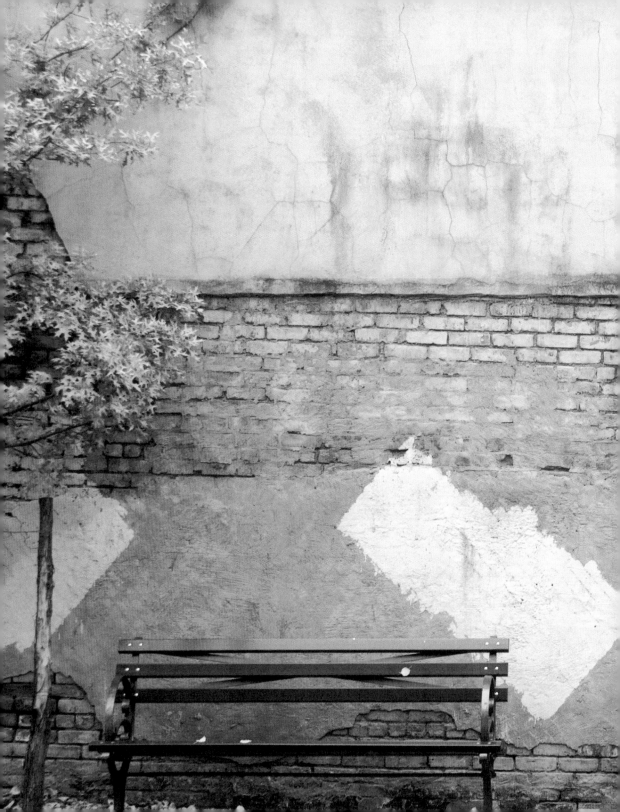

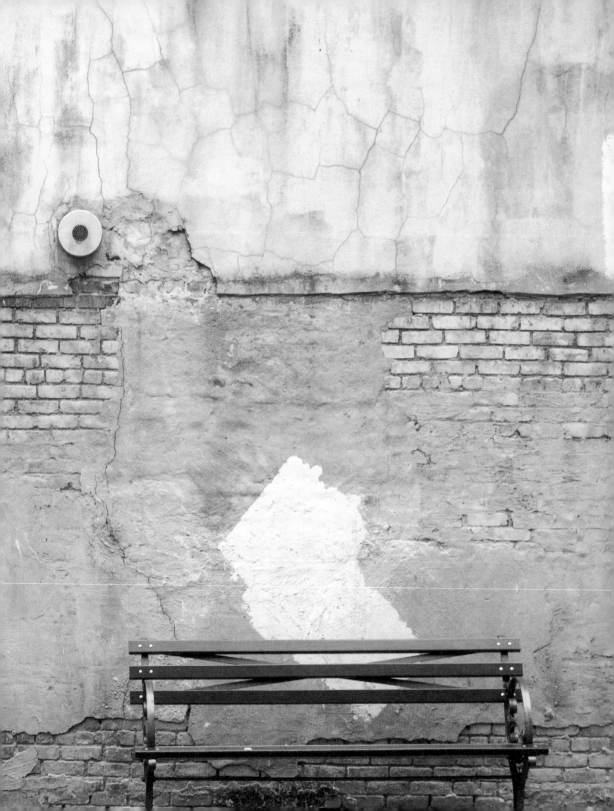

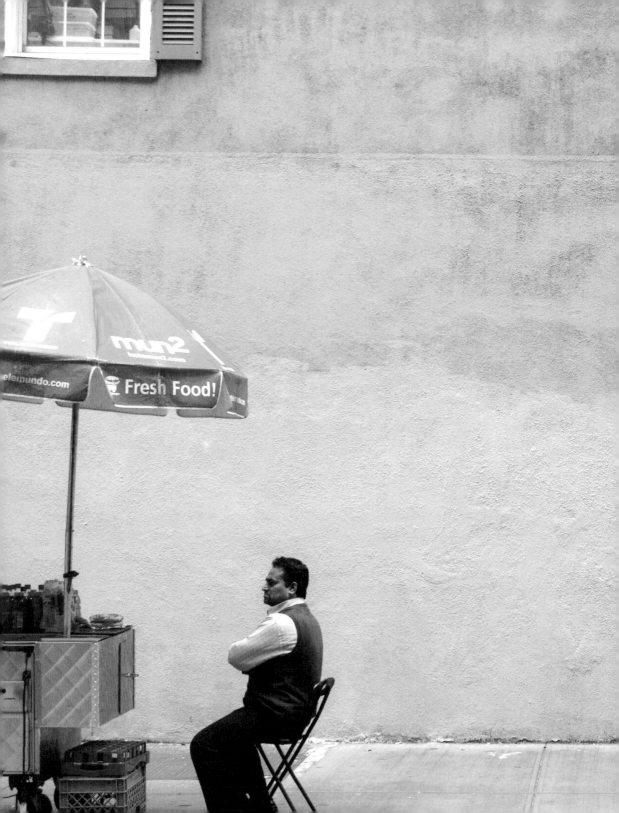

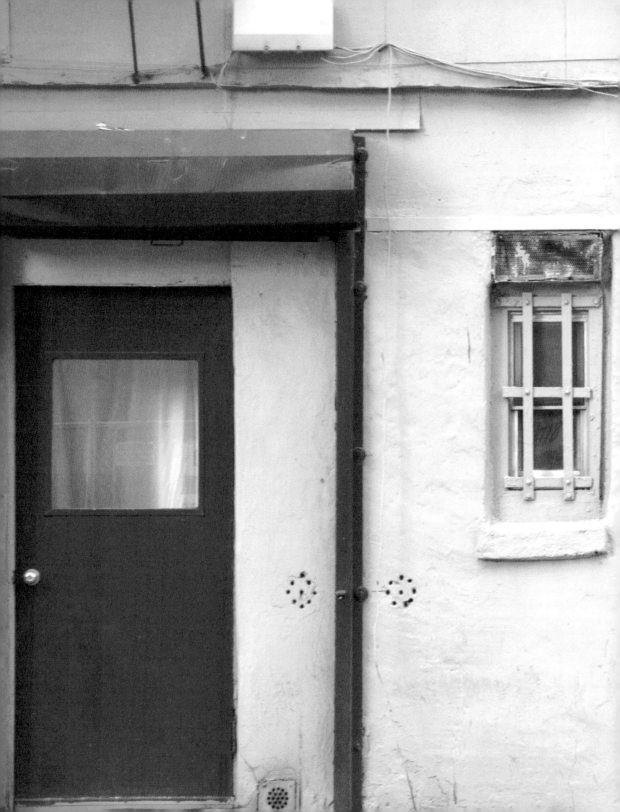

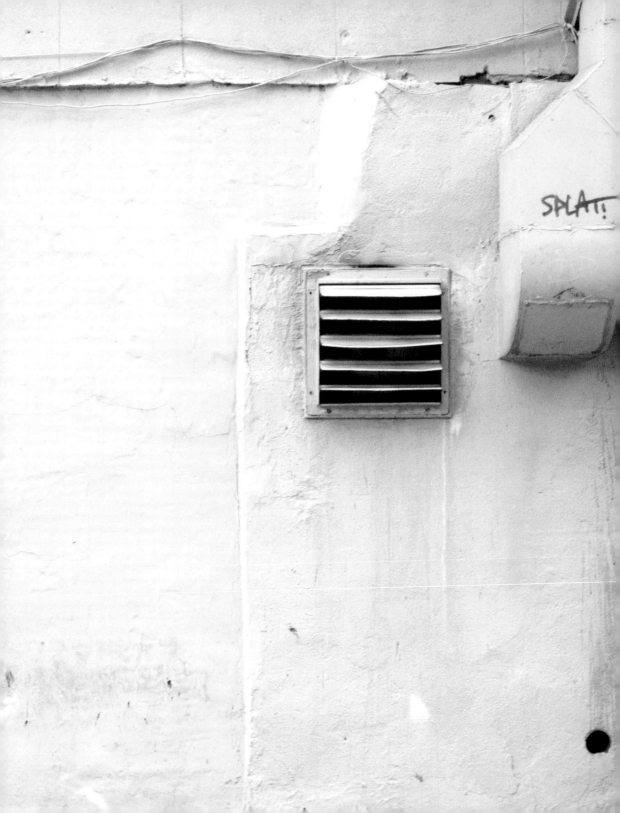

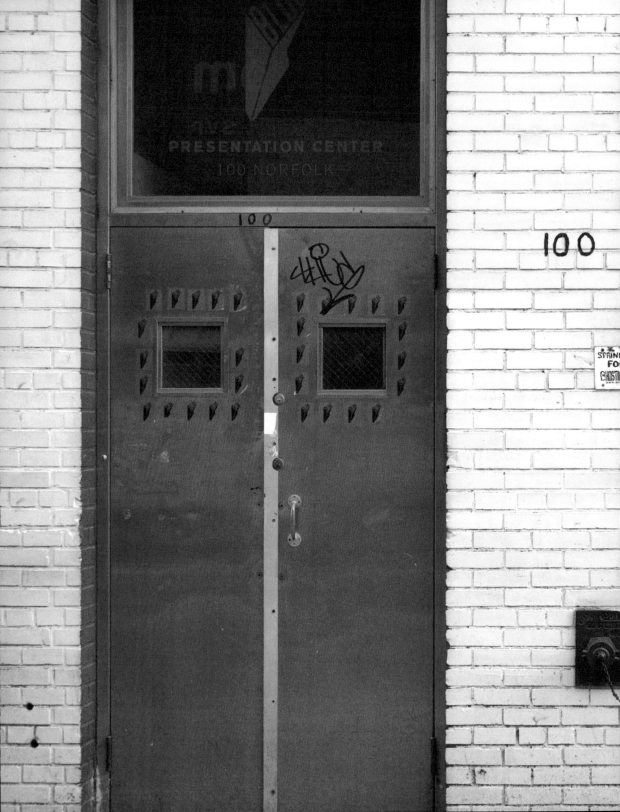

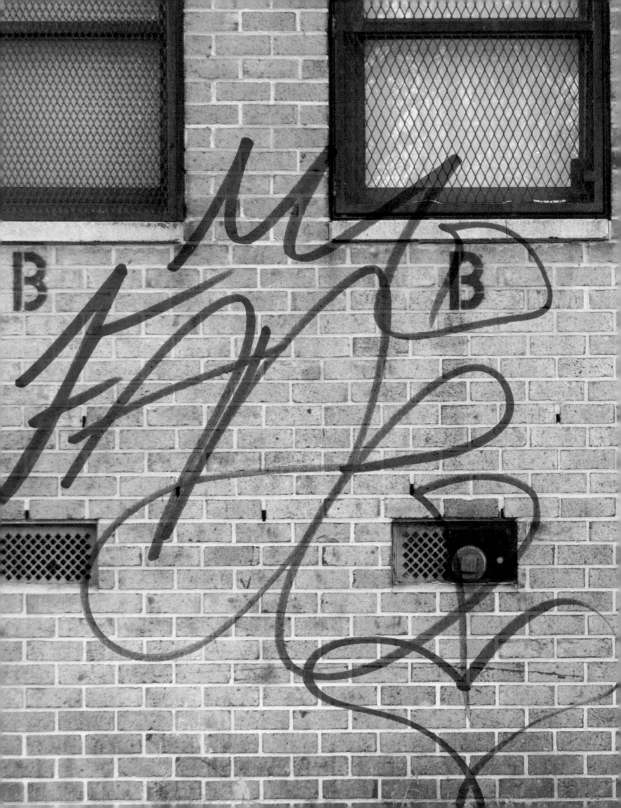

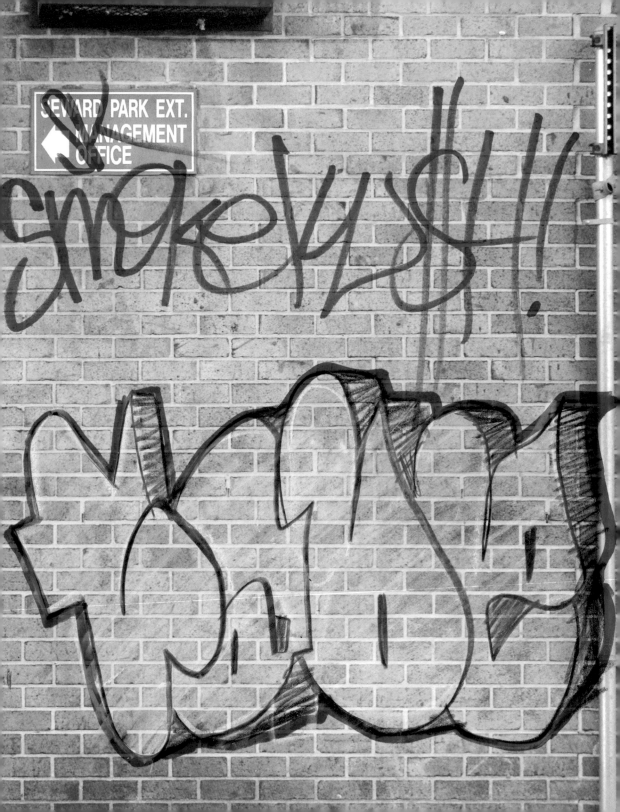

SEWARD PARK EXT.
MANAGEMENT
OFFICE

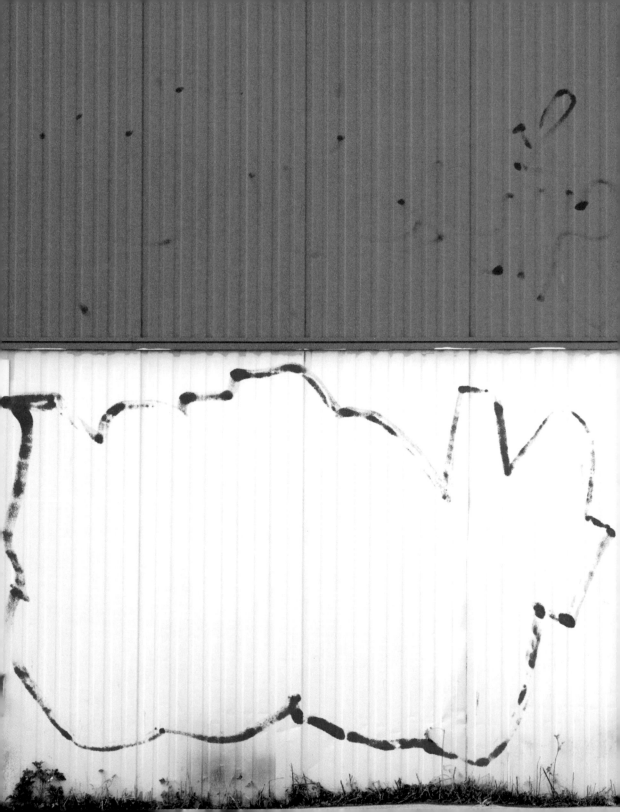

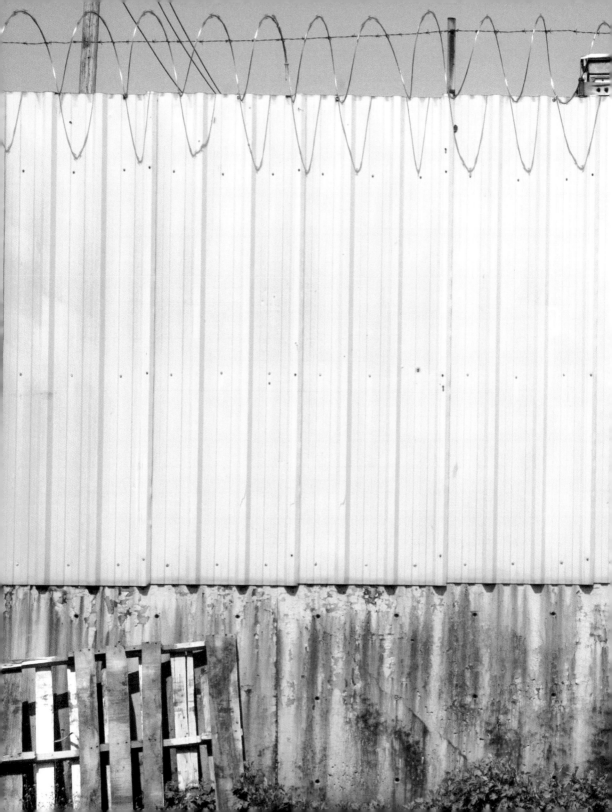

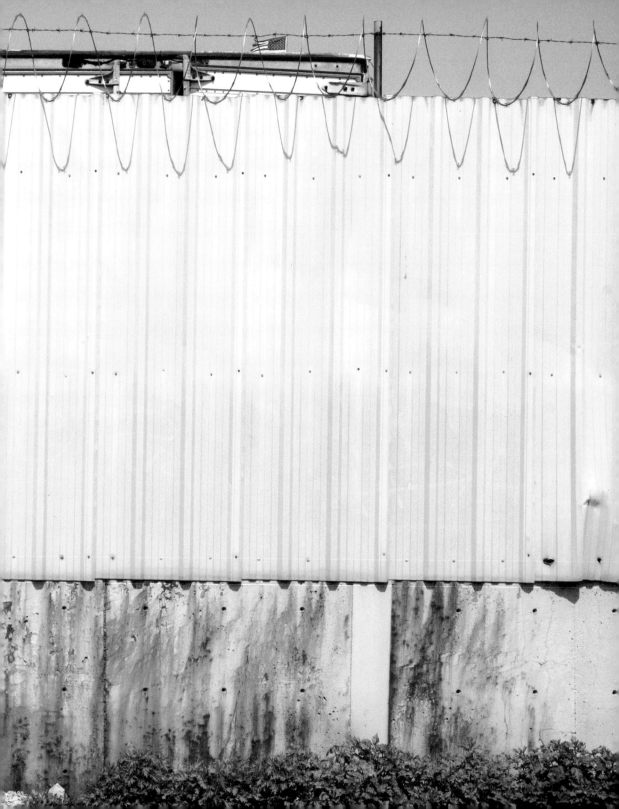

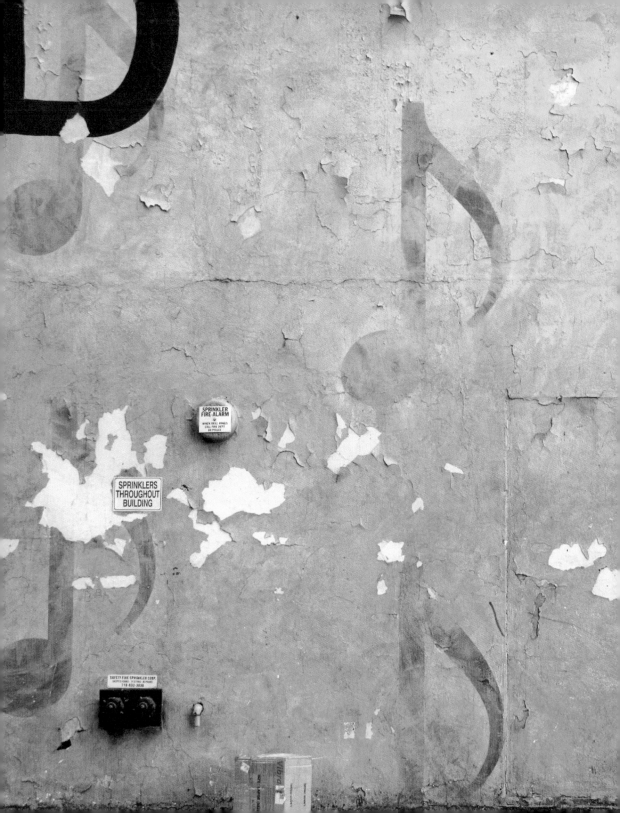

SPRINKLER
FIRE-ALARM

WHEN BELL RINGS
CALL FIRE DEPT
OR POLICE

SPRINKLERS
THROUGHOUT
BUILDING

SAFETY FIRE SPRINKLER CORP.
718-632-3838

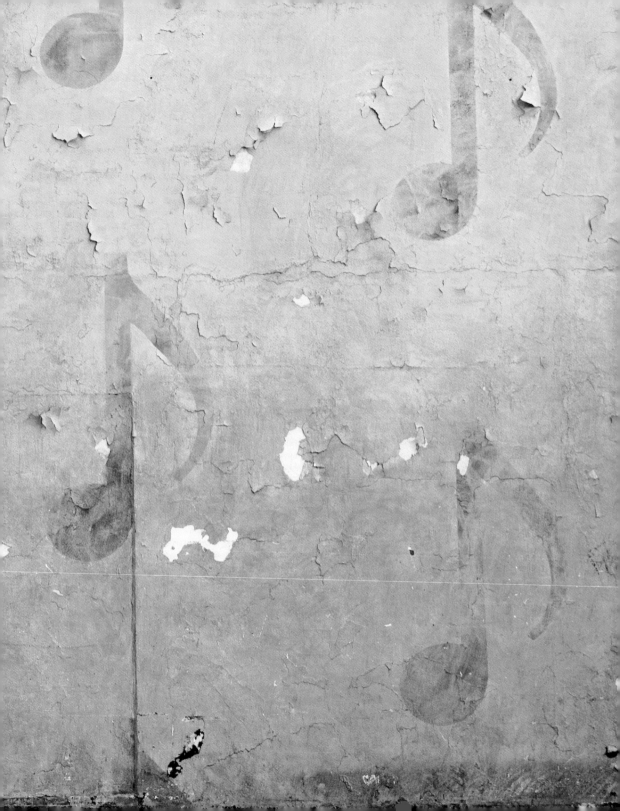

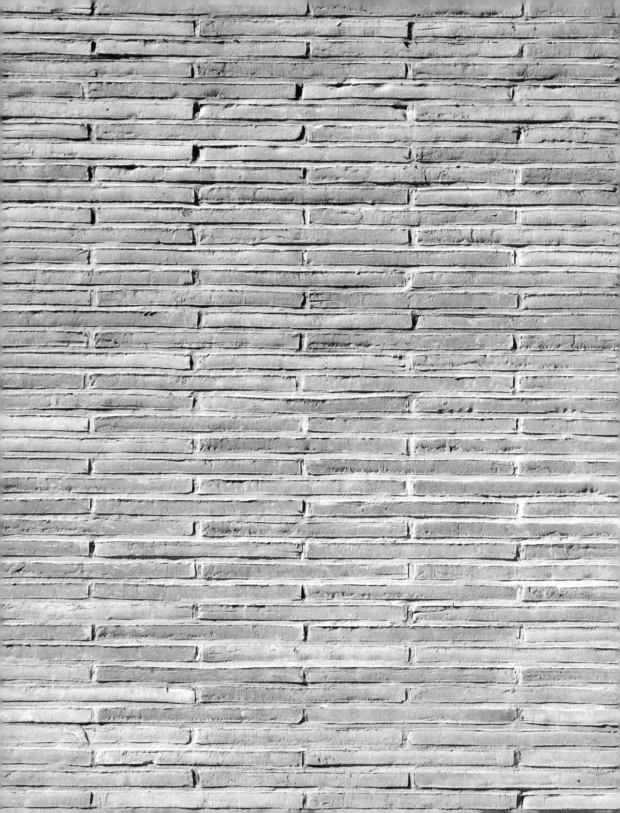

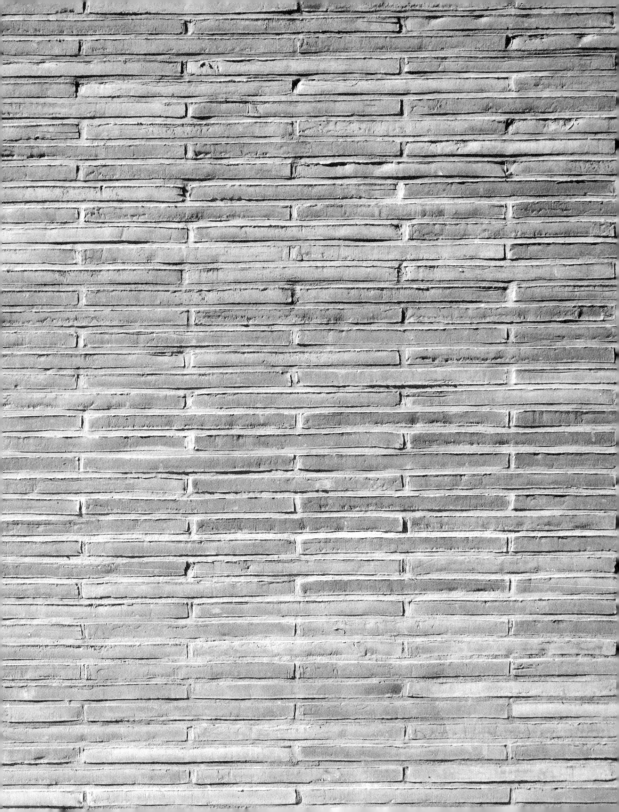

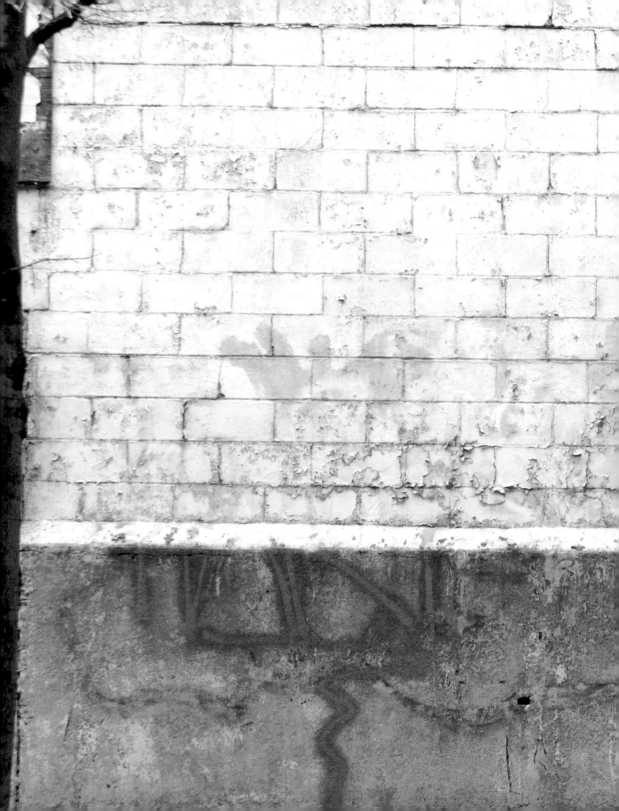

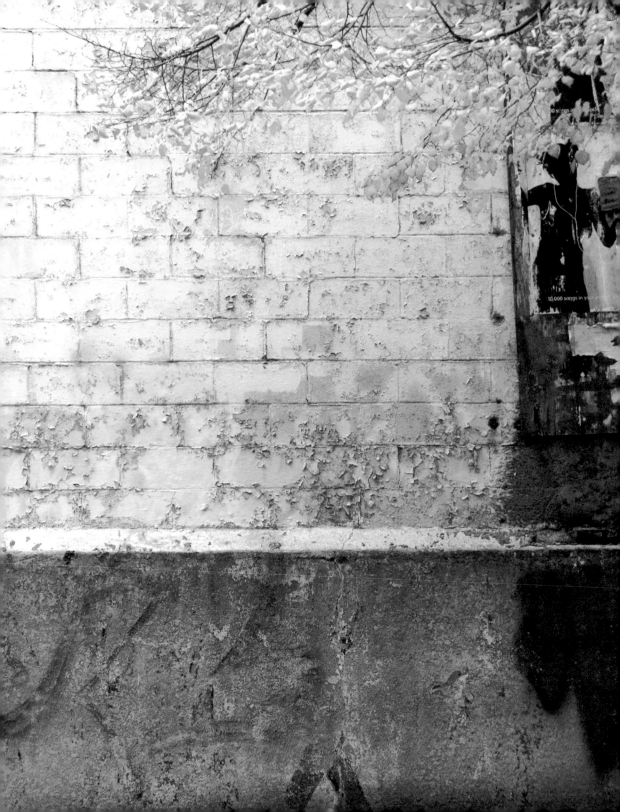

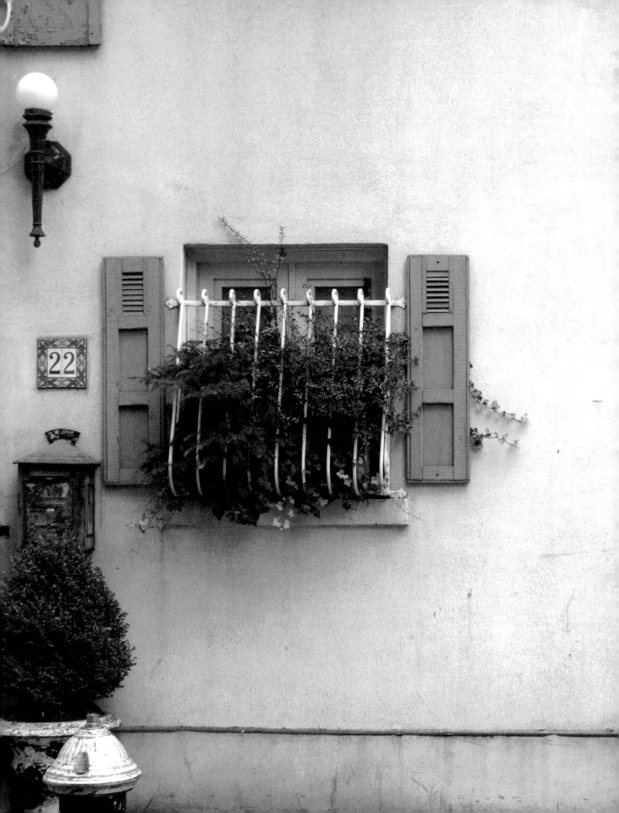

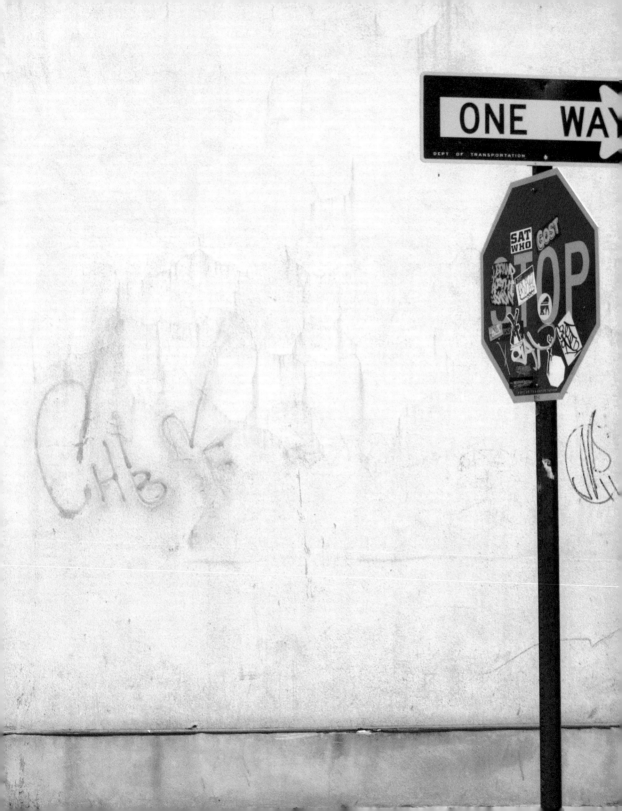

100 TRINITY PLACE

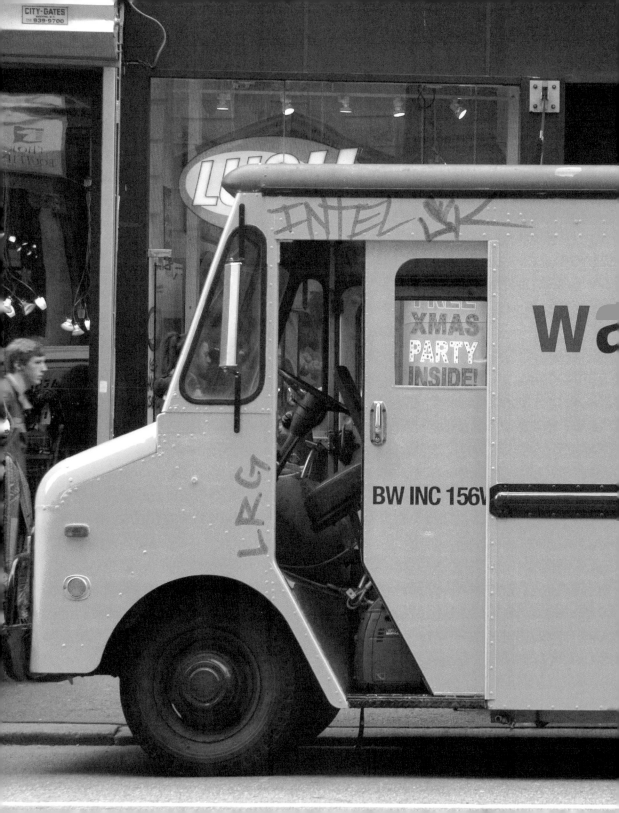

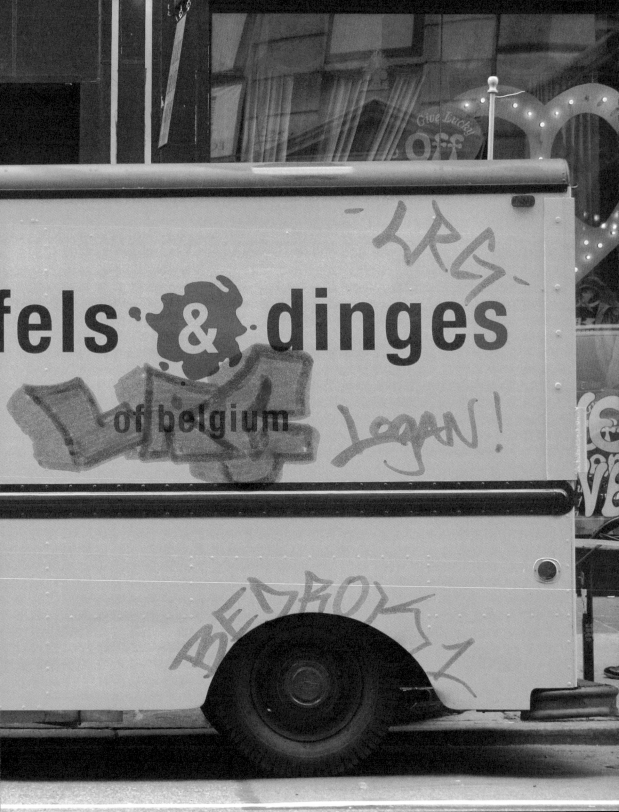

6th

Washingto

Comr

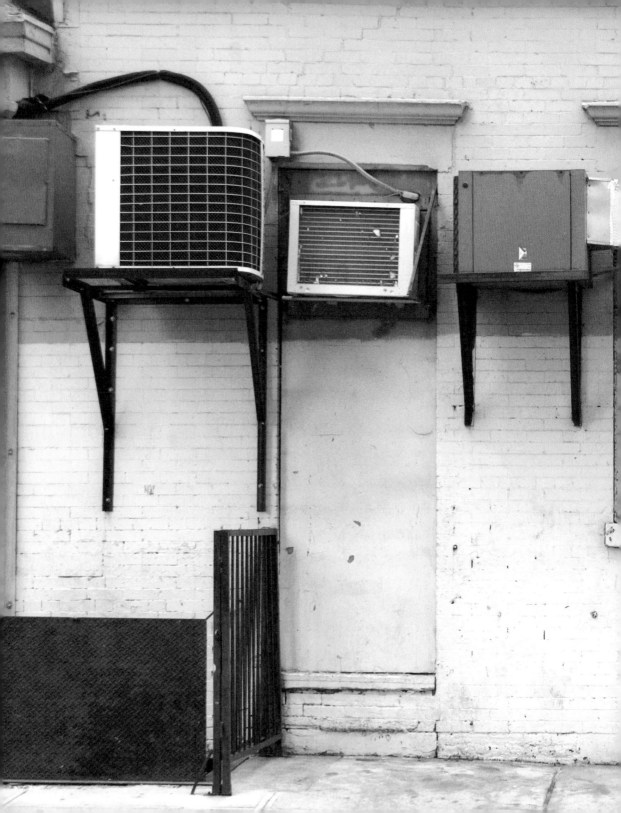

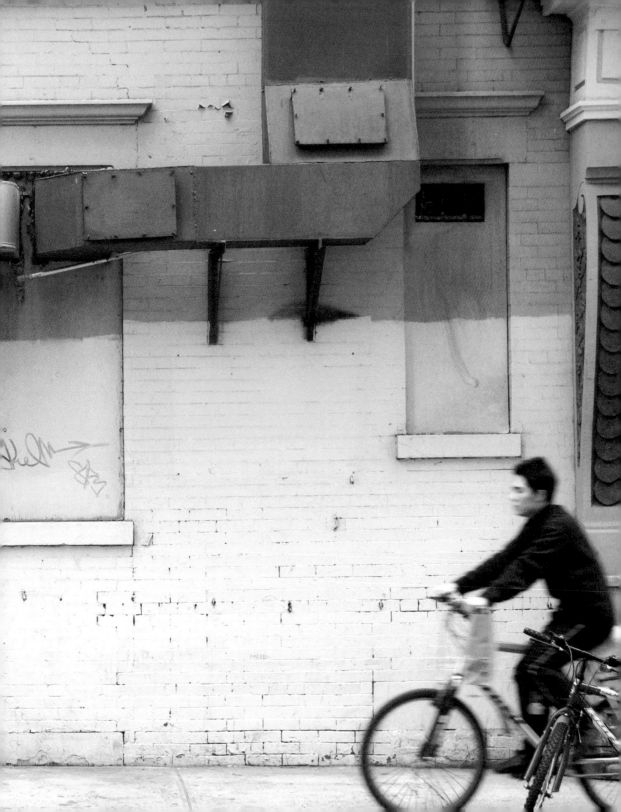

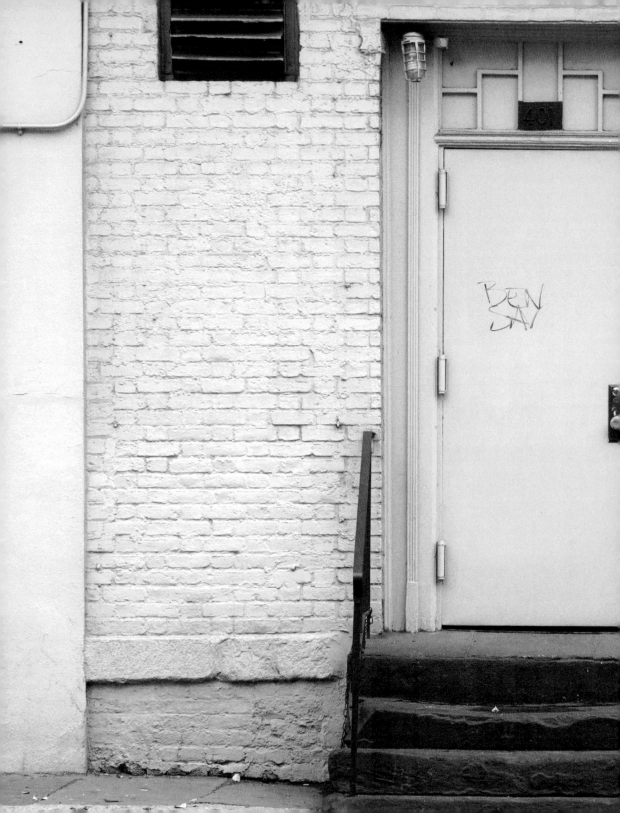

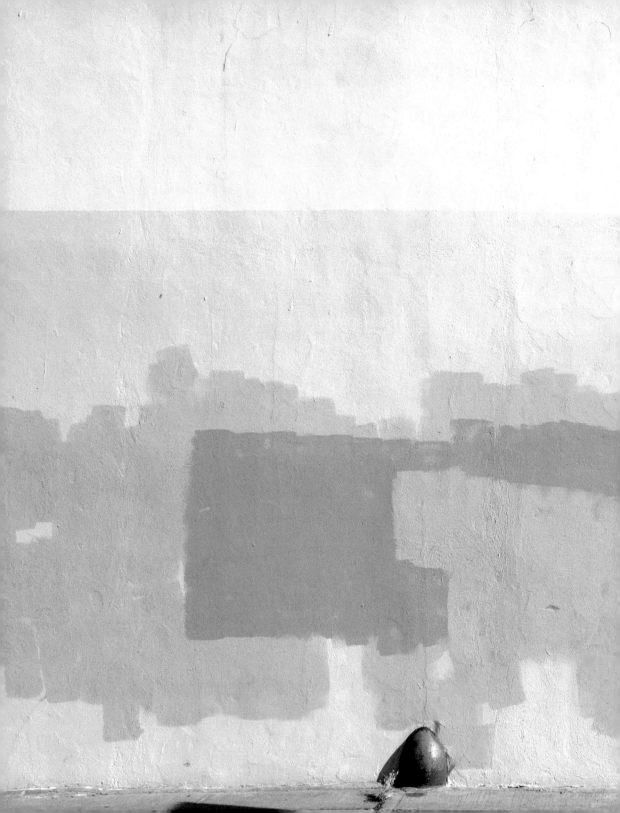

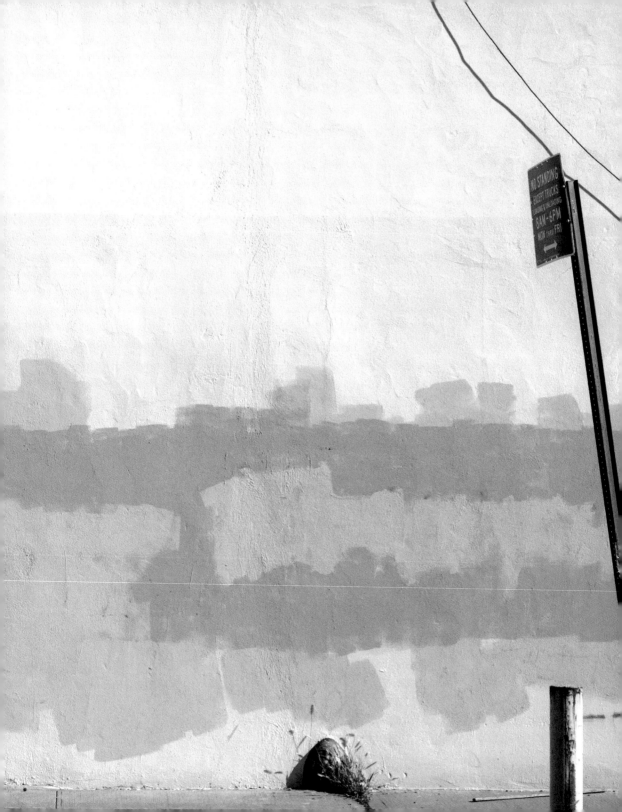

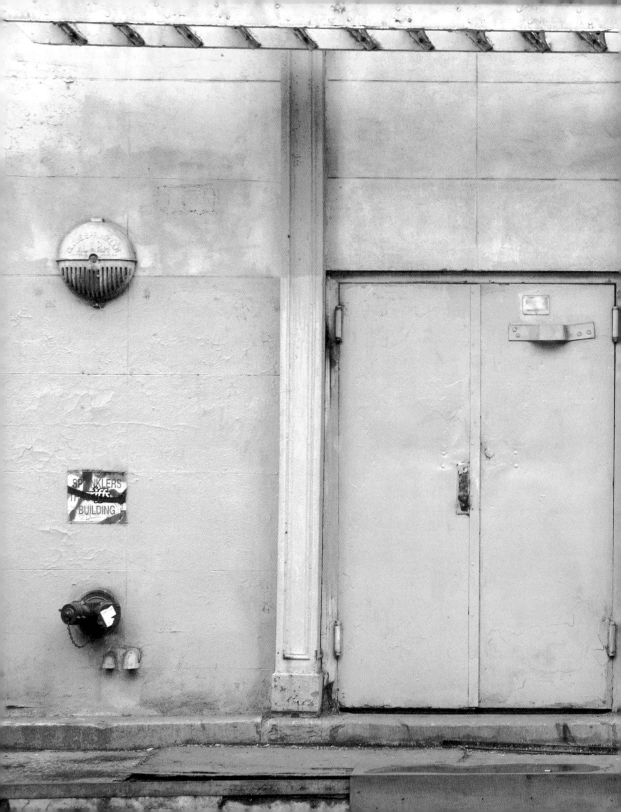

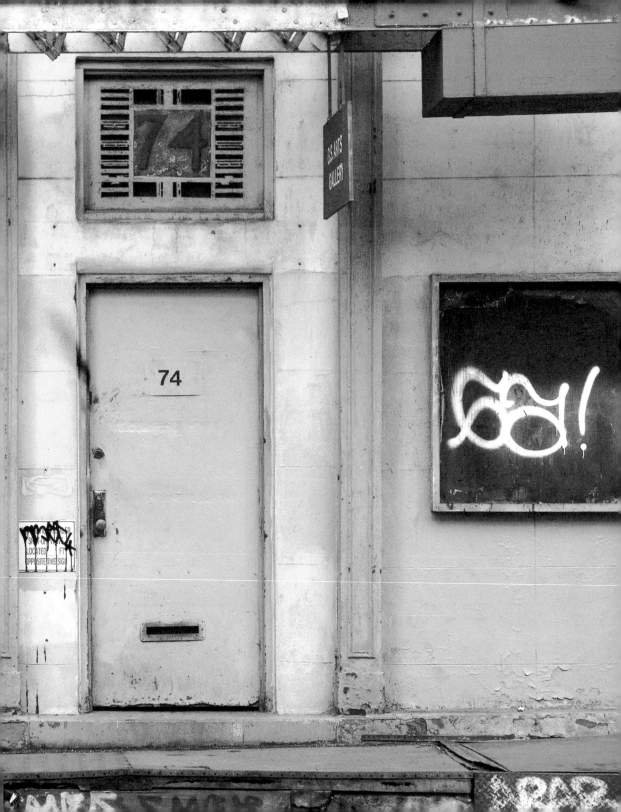

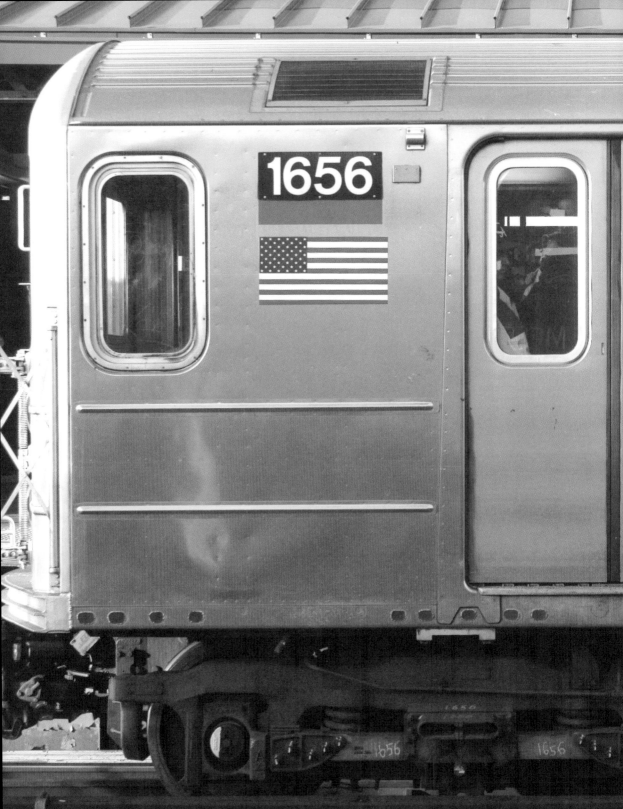

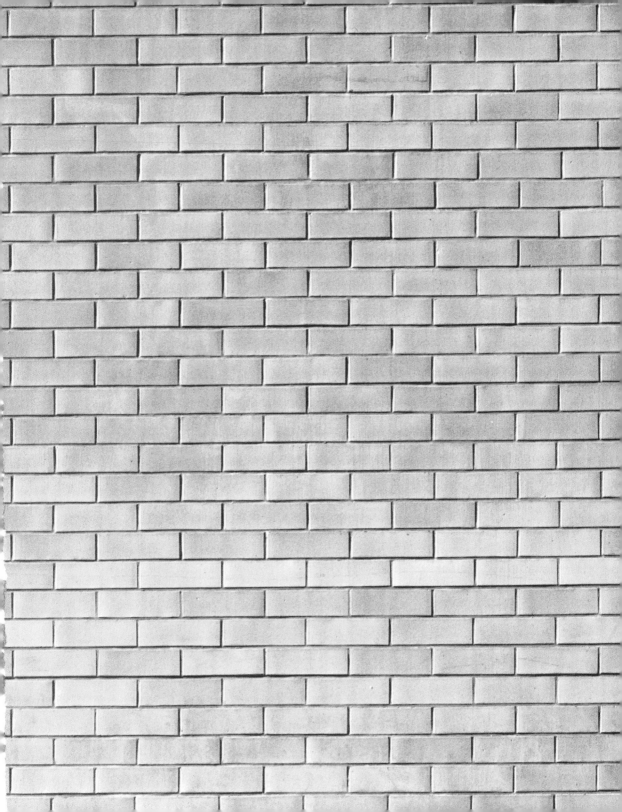

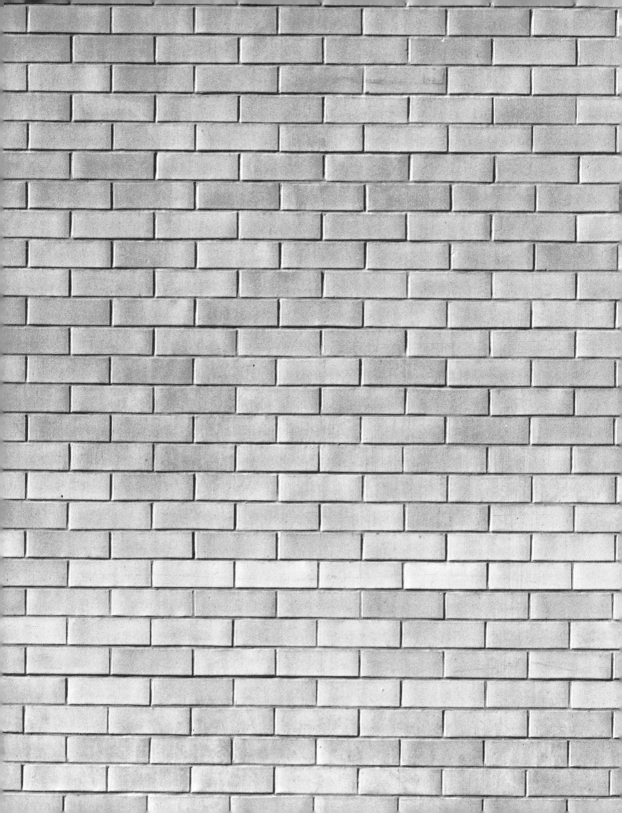